U0125613

2020 年北京市民族艺术学高精尖课题项目成果　项目编号：ART2020Y08
国家艺术基金 2022 年度传播交流推广资助项目　项目编号：2022-A-04-(086)-384

纹 以 载 道

中国民族纹样创新设计

徐进　编著

中央民族大学出版社
China Minzu University Press

图书在版编目（CIP）数据

纹以载道：中国民族纹样创新设计 / 徐进编著 . --
北京：中央民族大学出版社 ,2022.5（2023.3 重印）
ISBN 978-7-5660-2031-4

Ⅰ . ①纹… Ⅱ . ①徐… Ⅲ . ①纹样设计 Ⅳ . ① J51

中国版本图书馆 CIP 数据核字 (2021) 第 278895 号

纹以载道 —— 中国民族纹样创新设计

编 著	徐 进	
翻 译	苗天野	
策划编辑	赵秀琴 门泽琪	
责任编辑	门泽琪	
责任校对	何晓雨	
封面设计	杨茗惠	
创作指导	胡柳 杨宁	
出版发行	中央民族大学出版社	
地 址	北京市海淀区中关村南大街 27 号	
邮 编	100081	
电 话	（010）68932218（总编室）	
经 销 者	全国各地新华书店	
印 刷 厂	北京佳信达恒智彩印有限公司	
开 本	1/16	
成品尺寸	190mm×260 mm	
印 张	14.25	
字 数	101 千字	
版 次	2022 年 5 月第 1 版 2023 年 3 月第 2 次印刷	
书 号	ISBN 978-7-5660-2031-4	
定 价	158.00 元	

版权所有 翻印必究

【纹以载道】

纹样是人类历史记忆的留存，是文明起源、传承与发展的永恒载体，传递着自然审美的内在法则与哲学思考。

——徐 进

Patterns for TAO

Chinese traditional patterns and designs are the essence imprinted in the memories of human historical development, which provide an eternal nexus for the origin, inheritance and prospering of civilization; meanwhile, they deliver the internal rules and philosophical thinking of the aesthetics of nature.

——Xu Jin

序 —— 永生的图案

读徐进女士编著的《纹以载道》，勾起多年前的记忆，关于色彩，关于图案与绘画之间的联系，以及永恒的秘密。

2000 年，在大理见到一片老绣片，色彩美得不可思议，以至于我完全注意不到上面的图案，只看见由种种蓝灰、紫灰、点缀的暖灰色所合成的雅致而闪闪发亮的银灰色调画面，那简直是纳比派大师维亚尔的作品。还有很多美丽的绣片，用色之大胆，造型之出乎意料，图案组合之奇妙，让我这个被现代美术教育规训的人感到惊奇。可惜，绣片的价格不是当时还是学生的我所能负担得起的，只能默默赞叹，不知道它出于哪一位母亲、哪一个色彩天才的女性之手。

小时候看妈妈做枕套、绣带或被套，都要绣上花鸟或者图案。后来我学画画，懂得一点绘画知识，再看妈妈的绣片，注意到那些过渡色和灰色是由各色的彩线交织混合而成的，这可不就是印象派的色彩分离吗。最早的印象派应该是古时候默默无闻的女人，她们没有学过色彩理论，但是懂得怎样运用同类色、对比色和互补色，也懂得色彩分离与混合。看来，美与和谐先于理论而在，色彩真的是女性的，而造型是男性的。

古时候，人们不但用图案纹样来装饰生活，设计家徽、族徽、国徽，还相信他们所绘制的图案纹样具有通灵的力量，可以祝愿人类的繁殖与生产，可以干预自然界的风雨阴晴。通过纹样，我们得以形象地感受到各民族的喜爱与信仰、历史与神话。西南少数民族服饰的颜色和图案，有些还遗留着青铜时代的古风。据我模糊的印象，在青铜时代，从欧亚大陆到美洲，图案纹样与色彩有许多相似，也许图案纹样里隐藏着文明的起源与传播交流。

西方绘画是在模拟现实世界的实践中发展成熟起来的，而据我观察分析，商周时期以来，中国绘画受到图案纹样的巨大影响，在汉魏六朝才逐渐成熟起来，历程漫长。因此六朝绘画有一种介于图案与绘画之间的美。

最早吸引我的是敦煌的藻井图案和上古的漩涡纹，因为藻井图案的颜色古雅，漩涡纹与圆形的组合俨然显示了天体的运动方式，向我召唤梵高的《星空》与《向日葵》。抽象的图形与情感有着直接的联系，等边三角形与矩形冷静、均衡，圆形与弧形是流动的，而漩涡纹令人激动，感到迷幻。具象的图案纹样，比如动植物纹样从自然中提炼而来，抽象的几何图形却是由几何图形自身推演而成，从简单到复杂，三角形，矩形，菱形，五角形，八角形，乃至复合的图形。也许因为多边形具有方位指向，先人把他们的宇宙观放进了几何图形里。据阿城先生分析，苗族图纹里藏着中华古老文明的秘密——河图与洛书。

绘制图案纹样的先人们没有写实和几何的界限，他们巧妙组合两者，构成一个具象与抽象、感性与理性的世界。几千年前，他们早已懂得用一两种或三四种元素组合，排出二方连续、四方连续，指向无限与循环。他们也懂得分解图案然后重组，就像20世纪的立体主义艺术家。

抽象的几何图形属于理念世界，来自人类的推理与演化能力。按古希腊的观点，现实世界是理念的投影，如此说来，人类具有神性，因而有幸"看见"世界的"真相"，并描绘下来。

以上，是我所理解的"纹以载道"。

花开了，终究要谢落。千年的树也有枯死的那一天，看似坚固的事物，比如教堂、长城、钢铁也在风化、生锈。画里的花比真实的花长久，然而纸终究要发黄、毁坏直至消失。写实画里的鲜花是定格的瞬间，令人联想起青春的美好，却非长久。只有看南宋吴炳《出水莲》、元代郑所南《墨兰》那样的画，我从未想着画里的花朵会枯萎，因为这些画有着图案般的美。

万物皆有生灭，唯图案永生。

在绘画里，动植物的形态是真实的、个性的、也是瞬间的，而具象与抽象图案却都是共性的、普遍的、理念的，因此是永恒的。现实世界的事物总归会毁坏，理念世界不会。永恒如理念，图案是永生的，即便强悍如宗教，也毁灭不了纹样。佛教和基督教曾经反对偶像崇拜，但都保留图案纹样。伊斯兰教反对偶像崇拜最为彻底，千年来取消所有具象艺术，只留下纹样。没有图案纹样，就失去最后的象征与美的装饰，无论是礼拜堂还是尘世生活，都变成一片荒漠。

然而，现代文明使得我们的传统图案纹样正在生活中消失，庶几成为"文化遗产"或"藏品"。"永生"的理念世界毕竟是无形的，而图案纹样是有形的，唯有依附于生活应用，才能得到真的传承与发展。而今民间"现代化"，图案纹样正失去了过去深厚的土壤，幸好在学院里，古老的图纹依然被学习、被研究，被开发应用。《纹以载道》记录了徐进女士与她的学生们这些年对纹样图案的研究和应用的尝试，希望有益于读者诸君。

韦羲

2021年12月

目 录
CONTENTS

第五章　综合材料之纹样应用 /169
Chapter5 Pattern Application on Comprehensive Materials

前　言

　　自古以来，无论是自然造型还是几何符号的纹样在建筑、服饰、生活器具上历代相传，无声地传承着民族文化。德国哲学家恩斯特·卡希尔认为它是一种通过不言而喻或约定俗成的习惯或者通过某种语言法则去标示与其本体不同的另外事物，从哲学角度揭示了符号纹样与自然形象的因果关系。

　　中华民族历史悠久，民族文化灿若星辰。"天人合一"是中国古典艺术的精神内核，先民们认为人类处于自然之中，自然与宇宙万物相关联，"天地者，万物之父母也。"自然既是物质的实体，又是玄奥的"道"，即在冥冥之中的宇宙。人是有生命的躯体，与自然相通。空灵不空，空白非白，虚实交融，有无相生，这些理念在民族纹样中得以充分展现。

　　中华民族纹样是值得我们自豪的艺术瑰宝，如何研究、传承和利用好民族文化资源是需要我们持续耕耘的课题。自2004年以来，笔者在中央民族大学教授"图案"课程已有16个春秋，师生们利用假期远赴西藏、贵州、海南等地，走进村寨、民间艺人的手工作坊，采访当地手工艺人，考察地方博物馆，获得了许多宝贵的第一手资料，逐渐形成了一套独特的课程研学体系。

　　本书分为"花鸟鱼虫与动植物纹样""吉祥神兽与龙凤纹样""文字符号与人物纹样""星辰天象与几何化纹样""综合材料之纹样应用"五个部分，汇集了四百多幅纹样作品，皆为师生在田野调研的基础上临摹绘画或者电脑软件绘制再创作的美术作品。

　　美术作品的美在于细致入微的表达——历经岁月洗礼后褪色的五彩丝线与针脚处的微尘，无一不被关注，这些年轻的艺术工作者们努力用看似普通的彩色铅笔和水粉复刻出老绣片手工织造的质感，透过笔画仿佛能感受到绣娘的一针一线。而铅笔素描描绘出的银饰吊坠图案，黑白线条刻画的金属质感似能听闻清脆悦耳的银铃叮当。

　　这些作品虽然还略显青涩和稚嫩，却依旧让笔者对中华民族纹样的广阔创新前景充满了信心，年轻学生的独特创新视角将为传统民族纹样在当代社会中的传承发展注入新的生命力。

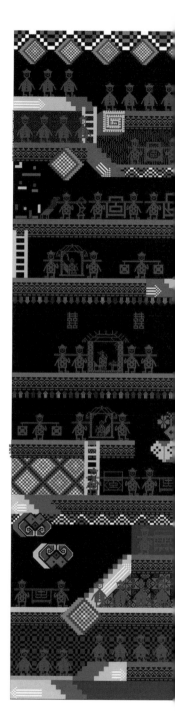

丝路之美（蒙古族、维吾尔族、羌族、回族、哈萨克族、藏族）

The beauty of the Silk Road (the Mongolian, Uygur, Qiang, Hui, Kazak, and Tibetan ethnic groups)

CHAPTER 1
FLOWERS, BIRDS, FISH, INSECTS, ANIMALS, AND PLANT PATTERNS

第一章 | 花鸟鱼虫与动植物纹样 |

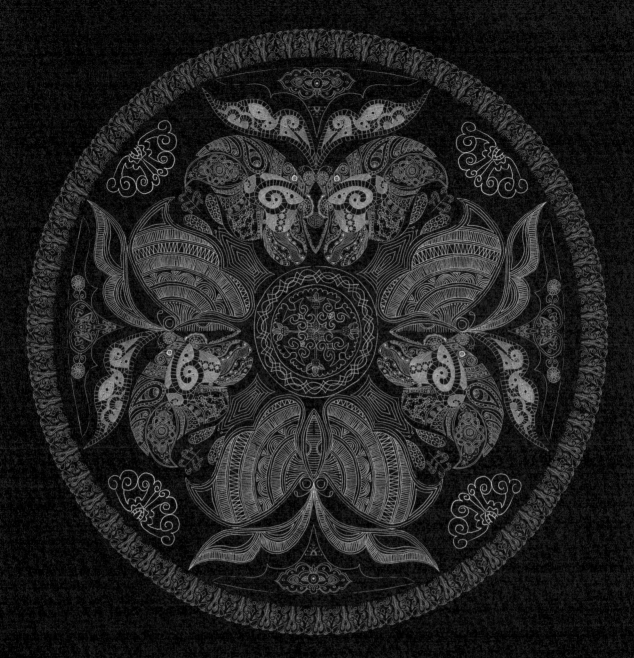

创作手法：铅笔绘画、计算机软件制图
Creative techniques: pencil drawing, computer software drawing

蝴蝶妈妈纹样创作（苗族）
The Mother Butterfly design (the Miao ethnic group)

　　苗族流传蝴蝶妈妈的传说甚多，《苗族古歌》："还有枫树干，还有枫树心，树干生妹榜，树心生妹留，古时老妈妈。""妹榜妹留"是苗语，汉语即是"蝴蝶妈妈"。

　　从"庄周梦蝶"到梁祝化蝶，"蝴蝶"还蕴含了爱情、生殖、生命等文化内涵，更有人首蝶身、蝶翼人身的图案流传。

The Miao people have many legends about Mother Butterfly. As an ancient song of the Miao ethnic group goes, "There is still a maple truck, there is still a maple heart. The trunk delivers Meibang, and the heart delivers Meiliu, our ancient mother". The Meibang Meiliu in Miao language means Mother Butterfly in Mandarin.

From "Zhuangzi dreamt he was a butterfly" to "The Butterfly Lovers", "butterfly" also carries cultural connotations like affection, reproduction and life. There are even patterns of the face of a human and the body of a butterfly as well as the body of a human with the wings of a butterfly.

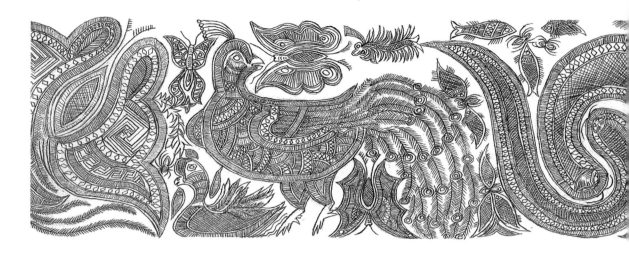

创作手法：铅笔手绘、计算机软件制图
Creative techniques: pencil drawing, computer software drawing

鼓藏幡纹饰（苗族）
The Guzang flag pattern (the Miao ethnic group)

　　该图案精细华贵，主要应用到苗族"鼓社祭"庆典的鼓藏幡上，由织锦和长幅蜡染布组成。蜡染注重染色纯净，虽不讲究华美雕饰，成型后却可令人叹为观止。图案自上至下全为自然纹样：蝴蝶纹、鱼纹、鹅纹、凤纹、龙纹、阴阳鱼纹、蜘蛛纹、蝉纹、蚂蚱纹、鸟纹、太阳纹、葛藤纹。但其又不拘泥于自然物原始原貌，而是进行艺术处理，在原始原貌的基础上夸张化，增加变化，一些动物只有部分肢体或轮廓，将这些互不相干的植物、动物巧妙组合到一起。

　　龙纹在苗族艺术中贯彻始终，作为远古图腾，龙寓意保佑子孙平安幸福。

This design is artisrically appealing, and is mainly applied to the Guzang flags used in the Miao people's celebration of the Guzang Festival. It consists of brocade and long batik fabric. On the one hand, batik pays attention to the purity of dyeing, which does not attach importance to gorgeous carvings, but can be breathtaking after molding. The patterns are all from nature, including the butterfly, fish, goose, phoenix, dragon, yin and yang fish, spider, cicada, grasshopper, bird, sun and kudzu. On the other hand, it does not stick to the original appearance of natural objects, but adopts artistic processing to exaggerate and enhance changes on the basis of their original appearances. Some animals depicted in the patterns have only partial limbs or outlines, while other unrelated plants and animals can be cleverly combined.

The dragon pattern is implemented throughout the Miao people's folk art, and as an ancient totem, it is believed to bless their children and grandchildren with safety and happiness.

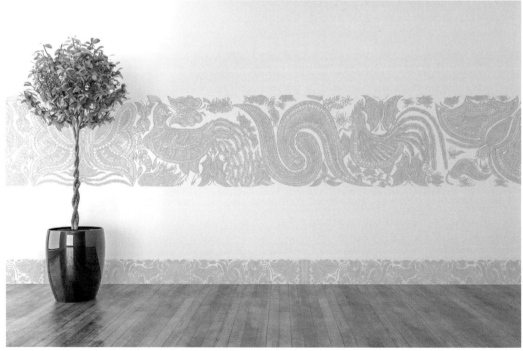

鼓藏幡纹饰文创设计
Cultural and creative design of the Guzang flag pattern

创作手法：铅笔手绘、计算机软件制图
Creative techniques: pencil drawing, computer software drawing

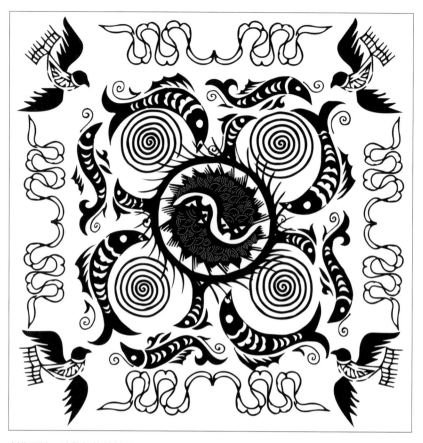

创作手法：计算机软件制图
Creative techniques: computer software drawing

玄鸟鱼纹图案创作（苗族）
The design of the mythical bird and fish pattern (the Miao ethnic group)

图案由漩涡纹、阴阳鱼纹、鱼纹、鸟纹组合而成。"鱼纹"蕴含着苗族人民期望子孙繁衍丰盛的美好意愿，鸟纹象征对上古图腾"玄鸟"的崇拜。纹样取材大自然，摈弃细节，做了大胆的变化和夸张的艺术处理。

The design is a combination of vortex, yin and yang fish and bird patterns. The fish pattern implies the good wish of the Miao people that their offspring would prosper, and the bird pattern symbolizes their worship of the ancient totem, the "Mythical Bird". Taking its elements from nature and discarding some details, the pattern has made bold changes and adopted exaggerated artistic process.

创作手法：计算机软件制图
Creative techniques: computer software drawing

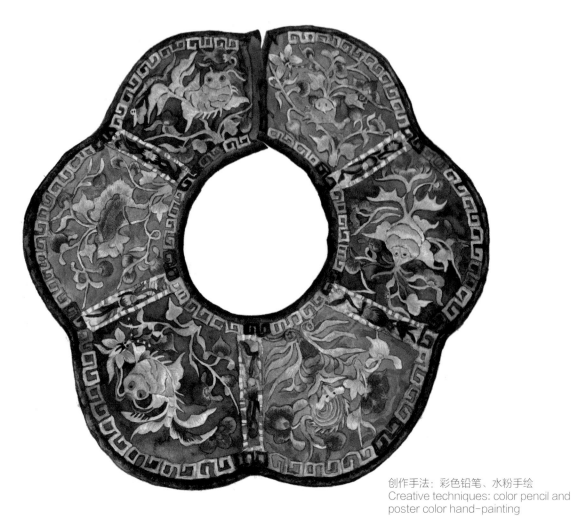

创作手法：彩色铅笔、水粉手绘
Creative techniques: color pencil and
poster color hand-painting

婴孩口水兜（苗族）[1]

A baby bib (the Miao ethnic group)

　　台江施洞地区的苗族刺绣历史悠久，工艺精湛，图案大多取材于日常生活中的动植物形象。苗族刺绣凝聚着苗族人的情感、期望、崇拜和信仰，它还记录着苗族人过去的历史和经历，被称为"穿在身上的历史"。此款台江施洞地区的口水兜采用平绣技法，即以剪纸作为刺绣图案底样，用丝线按照剪纸纹样，采用单针单线绣制而成，针脚排列密齐、均匀，图案立体感强。

The Miao embroidery in Shidong area of Taijiang has a long history. The craftsmanship is exquisite and the patterns mostly come from the images of animals and plants in everyday life. The Miao embroidery not only reflects the emotions, expectations, worship and beliefs of the Miao people, but also records their history and experience, and is thus called "the wearable history". This bib from the Shidong area of Taijiang adopts straight stitch, that is, the paper design is cut and used as the base of the embroidery pattern, and then a single piece of silk thread is embroidered stitch by stitch following the paper design. The stitches are densely and uniformly arranged, and the embroidery pattern presents a strong 3D effect.

1 实物来自贵州省黔东南州台江县。

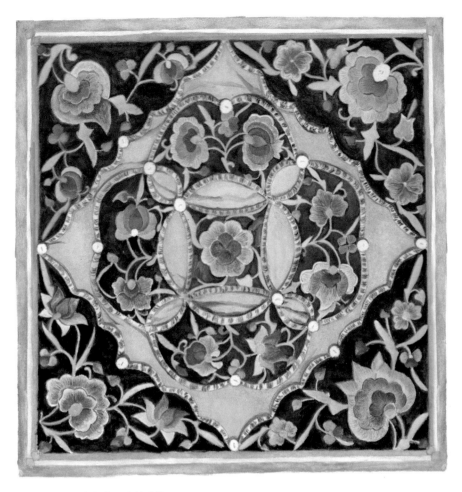

创作手法：彩色铅笔、水粉手绘
Creative techniques: color pencil and poster color hand-painting

破线绣绣片（苗族）[1]

A piece of embroidery with the split stitch (the Miao ethnic group)

　　此款毕节威宁的绣片采用破线绣方法绣制而成。破线绣通常将一根丝线分成6根或12根，用皂角汁打蜡后绣在布料上，垫以剪纸，逐针绣成。此款破线绣花卉图案，红绿色对比强烈、绣工精细、平滑光亮，拼接构图、饰以白色纽扣，别具一格。

This embroidery piece from Weining, Bijie is mad enploying the split stitch. The split stitch usually splits a silk thread into 6 or 12 threads which are then waxed with the Chinese Honey Locust juice and embroidered on fabrics. Such piece is embroidered with tracing paper and stitch by stitch. The flower pattern embroidered with split threads adopts the strong contrast of red and green colors. The fine, smooth and bright embroidered product is of spliced composition and decorated with white buttons to create its own uniqueness.

1 实物来自贵州省毕节市威宁县。

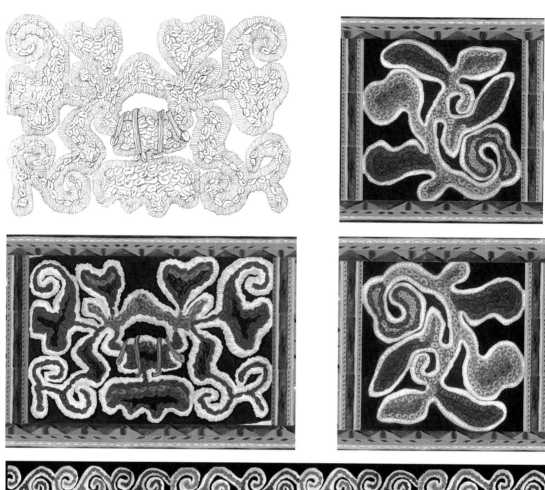

打籽绣背带（苗族）[1]

An embroidered strap with the knot stitch (the Miao ethnic group)

　　打籽绣是用线条绕成粒状小圈，绣一针，形成一粒"籽"，故名打籽绣。打针法适宜绣制装饰性较强的图案，美观大方且坚固耐用。苗族打籽绣常见图案有蝴蝶纹、涡花纹、植物纹、龙纹、鹡宇鸟纹等。此件背带以抽象的蝴蝶纹、花草纹、涡花纹及几何纹为主，黑底色上饰以灰绿、玫红、深红、蓝色纹样，白色镶边。整件背带绣工精美，色彩和谐沉稳又不失鲜明活泼，具有极高的审美价值。

The knot embroidery creates knots with threads. Each stitch forms a "knot", The knot stitch is suitable for embroidering beautiful and durable patterns for decorative purposes. The common patterns of the Miao people's knot embroidery include butterfly, vortex, flower and grass, dragon, Jiyu bird, etc. This strap is designed mainly with the abstract butterfly, flower and grass and vortex pattern. The black background is decorated with gray-green, rose red, crimson and blue patterns, with white borders. The entire strap is beautifully embroidered, and the colors are harmonious, vivid and lively, which has a high aesthetic value.

1 实物来自贵州省黔东南州台江县。

创作手法：铅笔、水粉手绘
Creative techniques: pencil, poster color hand-painting

创作手法：计算机软件制图
Creative techniques: computer software drawing

破线绣绣片（苗族）¹
A piece of embroidery with the split stitch (the Miao ethnic group)

此绣片纹样来自女装衣袖上的鹡宇鸟纹。

1 实物来自贵州省黔东南州台江县台拱镇。

创作手法：计算机软件制图
Creative techniques: computer software drawing

破线绣图案创作（苗族）
Pattern design using the split stitch (the Miao ethnic group)

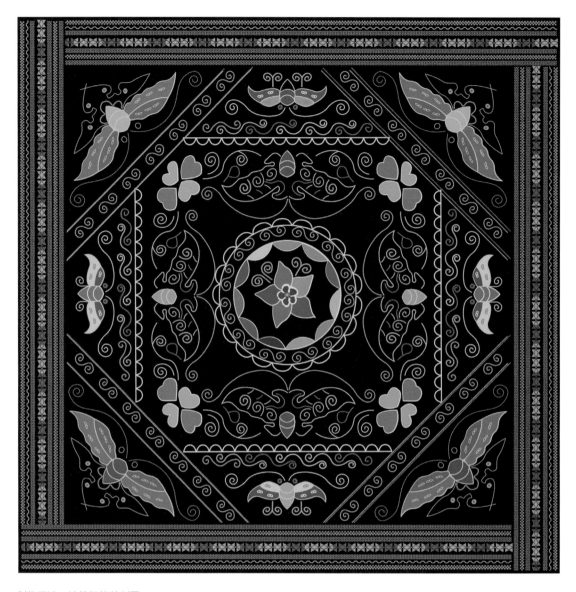

创作手法：计算机软件制图
Creative techniques: computer software drawing

锁边绣背带绣片（苗族）
An embroidered strap with the overcast stitch (the Miao ethnic group)

此款背带绣片为背带盖部分，来自贵州省黔东南苗族侗族自治州榕江县，刺绣技法为锁边绣，纹样以蝴蝶纹为主，辅以花草纹和几何纹样，黑底彩线，活泼灵动。

This strap is embroidered employing the overcast stitch, and is exquisitely designed with butterfly, flower and grass, and geometric patterns.

创作手法：计算机软件制图
Creative techniques: computer software drawing

锁边绣纹样提取与创作（苗族）
Extraction and design of the overcast stitch pattern (the Miao ethnic group)

创作手法：计算机软件制图
Creative techniques: computer software drawing

鸟纹、鼓面纹、蛙纹绣片（苗族）
A piece of embroidery with bird, drum and frog patterns (the Miao ethnic group)

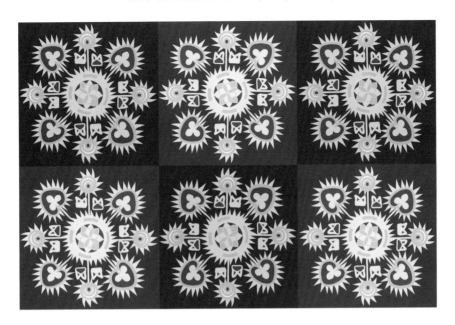

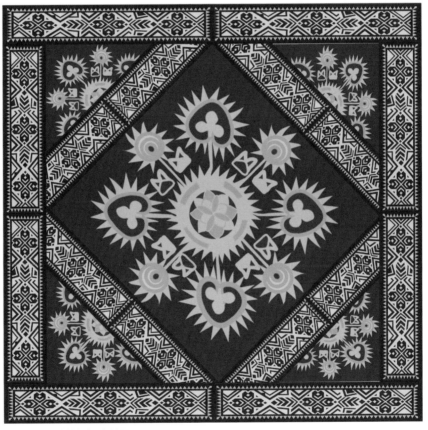

创作手法：计算机软件制图
Creative techniques: computer software drawing

鸟纹、鼓面纹、蛙纹创新设计（苗族）
Innovative design of bird, drum and frog patterns (the Miao ethnic group)

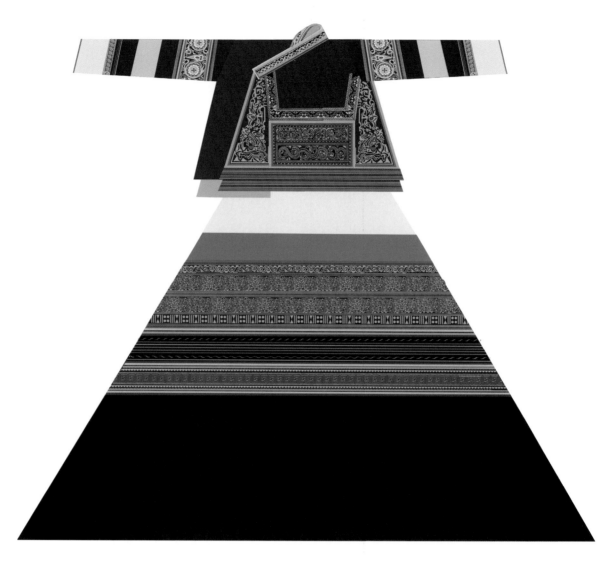

创作手法：计算机软件制图
Creative techniques: computer software drawing

女装（苗族）[1]
A female dress (the Miao ethnic group)

1　实物来自贵州省黔西南布依族苗族自治州安龙县。

创作手法：计算机软件制图
Creative techniques: computer software drawing

女装纹样提取（苗族）
Patterns from a female dress (the Miao ethnic group)

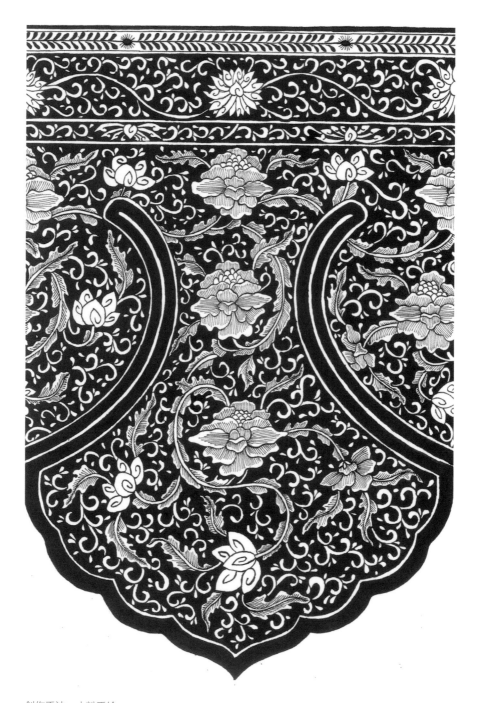

创作手法：水粉手绘
Creative techniques: poster color hand-painting

参考图片来源：[英]欧文•琼斯 编撰 . 中国纹样 [M]. 上海古籍出版社，2016：17.

青花瓷器纹样
Blue and White Porcelain Pattern

创作手法：水粉手绘
Creative techniques: poster color hand-painting

参考图片来源：[英]欧文·琼斯 编撰. 中国纹样 [M]. 上海古籍出版社，2016：121.

彩绘瓷器纹样
Colored Porcelain Pattern

创作手法：水粉手绘
Creative techniques: poster color hand-painting

参考图片来源：[英] 欧文•琼斯 编撰. 中国纹样 [M]. 上海古籍出版社，2016：111.

珐琅彩铜瓶纹样
Enamel Copper Bottle Pattern

创作手法：水粉手绘
Creative techniques: poster color hand-painting

参考图片来源：[英] 欧文·琼斯 编撰. 中国纹样 [M]. 上海古籍出版社，2016：177.

彩绘瓷器纹样
Colored Porcelain Pattern

创作手法：彩色铅笔、水粉手绘
Creative techniques: color pencil, poster color hand-painting

平绣背带绣片（壮族）[1]

An embroidered strap with the plain stitch (the Zhuang ethnic group)

此款壮族平绣背带绣片，由许多独立的花纹小块组成，以花草传统纹为主，其制作步骤是先将裁剪成形的图案根据需要贴在红、黄、绿、黑色绸缎上，再用与底色成补色、对比色系的绒线刺绣，最后镶接成完整的背带绣片。

This piece of embroidered strap with the straight stitch is composed of many separate pattern, and the traditional flower patterns are the main element.The procedure to make such embroidery piece is as follows, the image is first cut and pasted on the red, yellow, green and black silk as needed, then the woolen threads complementing and contrasting with the background colors are used for embroidery, and finally the piece is inlaid to complete the strap.

1 实物来自广西省河池市南丹县。

创作手法：计算机软件制图
Creative techniques: computer
software drawing

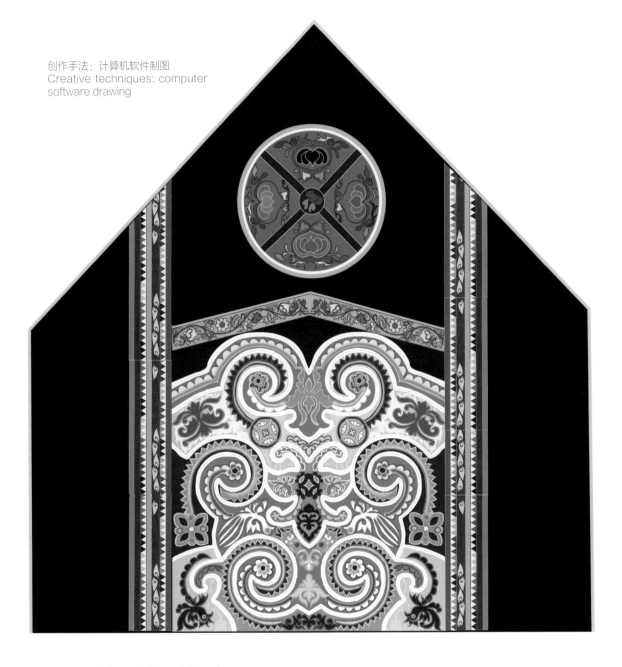

贴布绣背带（壮族）[1]

An embroidered strap with applique (the Zhuang ethnic group)

　　此款壮族背带中的纹样为左右对称的曲线，从整个造型来看，这个复杂奇妙的图形，和天极神纹样有着相似性，它应该是在模拟祭祀中的天极神。[2]

Symmetrical curve patterns appear on this embroidered strap. In terms of its shape and lines, this sophisticated pattern, akin to the God of the Celestial Pole, may have borrowed elements from the God of the Celestial Pole in sacrifice.

1　实物来自云南省文山壮族苗族自治州。
2　阿城. 洛书河图：文明的造型探源 [M]. 北京：中华书局，2015：90.

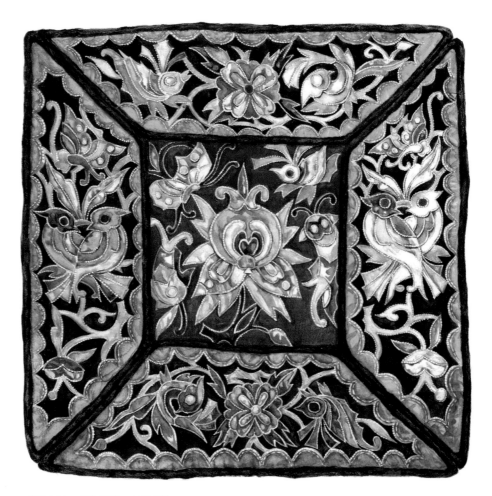

创作手法：彩色铅笔、水粉手绘
Creative techniques: color pencil, poster color hand-painting

贴布绣背带绣片（水族）

An embroidered strap with applique (the Shui ethnic group)

　　此款背带绣片是水族贴布绣，绣工精美、色彩艳丽，纹样以花鸟鱼虫、蝴蝶图案为主，黑底色与黑色、金色镶边有效调节了红绿的补色对比关系，双鸟的形象设计，生动有趣，独具特色。

This embroidered strap is made with exquisite embroidery and gorgeous colors. The patterns are mainly flowers, birds, fish, insects and butterflies. The black background and the black and golden borders effectively adjust the complementary contrast between the red and green colors. The interesting two-bird image is vivid and unique .

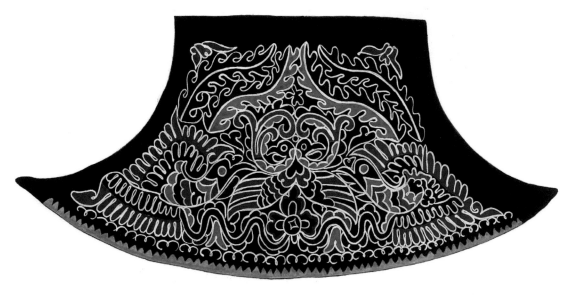

创作手法：水粉手绘
Creative techniques: poster color hand-painting

马尾绣围腰（水族）
A horsetail embroidery waistband (the Shui ethnic group)

　　水族艺术最具民族特色、最古老、世代相传的即是水族马尾绣，该技艺主要将马尾作为重要原材料。马尾绣涉及烦琐复杂的制作过程，成品华美精致、古色古香、结实耐用。刺绣图案古朴、典雅、抽象，并具有固定的框架和模式。马尾绣的第一步即是用马尾缠绕制成马尾丝，然后将马尾丝顺着纹样的边缘，一一盘缀出整个纹样的轮廓，随后在里边填充，可以应用彩色丝线、打籽或是绞针填充。最后，在绣面空隙处缝上少量的亮片。整幅绣样远远望去，如同银丝盘绕，蛇龙飞舞。

　　这件水族围腰采用黑色涂布作料，内绣五彩缤纷的花朵、蝴蝶、鱼等图案。

The Shui art most ethnic and oldest embroidery passed down from generation to generation is the Shui horsetail embroidery, a special embroidery technique that uses horsetail as an important raw material. The horsetail embroidery involves a cumbersome and complicated making process, and the finished embroidery is not only gorgeous and exquisite, but also antique, and durable. The embroidery patterns are simple and unsophisticated, elegant and abstract and have a fixed frame and pattern. The horsetail embroidery takes the horsetail piece as the axis and winds white wax optical fiber around it. The wrapped horsetail piece is then used to adorn the outline of the whole pattern, and the inside is filled with colored silk threads, seed stitches or chain stitches. Finally, a few sequins are used to fill the gaps on the embroidery surface. Looking from a distance, the whole picture seems to be made of silver wires and have a snake and a dragon flying around it.

This Shui people's waistbands are made of black coated fabrics with colorful flower, butterfly and fish patterns embroidered on the inside.

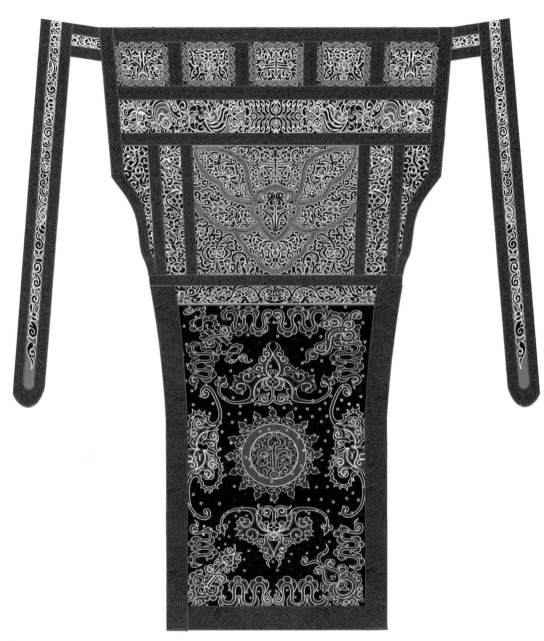

创作手法：计算机软件制图
Creative techniques: computer software drawing

马尾绣背扇（水族）
A horsetail embroidery Beishan (the Shui ethnic group)

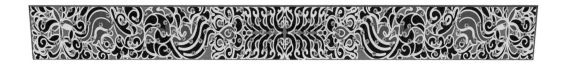

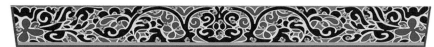

创作手法：计算机软件制图
Creative techniques: computer software drawing

马尾绣背扇纹样提取（水族）
Extraction of horsetail embroidery Beishan patterns (the Shui ethnic group)

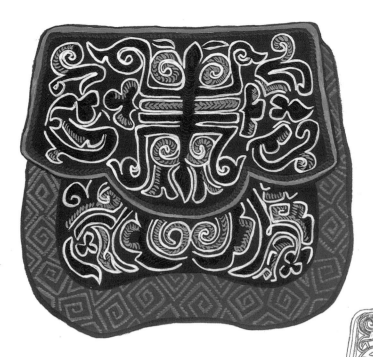

创作手法：水粉手绘
Creative techniques: poster color hand-painting

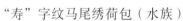

"寿"字纹马尾绣荷包（水族）

A horsetail embroidery purse with the "Shou" pattern (the Shui ethnic group)

　　马尾绣主要的内容有植物、动物，图案多讲究对称，常见如蝴蝶、葫芦、石榴、"寿"字等，包含多子多福、健康长寿之意。中心流动的花草曲线图案与边饰的几何纹形成了阳刚与阴柔的对比。可以看出形式多样、色彩丰富的马尾绣比较重视图案的统一与变化，也含有吉祥之意。

The main patterns of the horsetail embroidery includes plants and animals, and most of the patterns are symmetrical, such as butterflies, gourds, pomegranates and the character "Shou" which means more children for greater happiness, health and longevity. The flowing and curving plant patterns in the center and the geometric patterns at the edge form a contrast between masculinity and femininity. It can be seen that the diversified and colorful horsetail embroidery pays more attention to the unity and change of the patterns, which symbolizes auspiciousness.

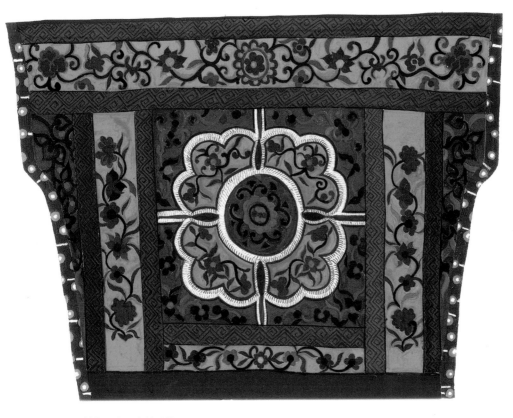

创作手法：水粉手绘
Creative techniques: poster color hand-painting

花草纹马尾绣背扇（水族）
A horsetail embroidery Beishan with the flower and grass pattern
(the Shui ethnic group)

　　水族常见的刺绣题材之一，即是花草纹。花鞋、衣边或是背带上，都会带有各种各样的纹样。水族人民认为"蝴蝶旁边的花是保护养育蝴蝶的，而两个凤鸟之间的花是来保护凤鸟的"，因此水族便形成了植物保护动物，动物保护人的特殊模式，对动物尊崇、对植物热爱，体现了水族人民对万物相生相长的认知。该花纹绣在背带上体现了人们对孩童的美好祝愿，希望花草、大自然呵护孩童成长。

One of the common Shui embroidery themes is the plant pattern. For example, their shoes, the edges of their clothes or their straps are often embroidered with various patterns. The Shui people believe that "the flower next to the butterfly is to protect and nurture the butterfly, and the flower between two phoenixes is to protect the phoenixes". Therefore, the Shui people have formed a special model that plants protect animals and animals protect humans. Their respect for animals and love for plants reflect their cognition that all things breed and foster mutually. The pattern embroidered on the strap reflects the Shui people's best wishes to their children, hoping that the plants and nature will nurture their children.

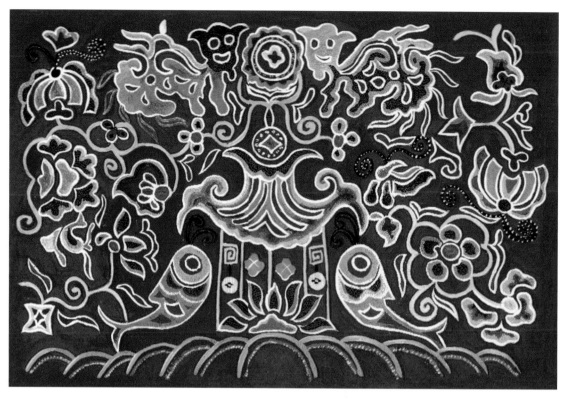

创作手法：水粉手绘
Creative techniques: poster color hand-painting

花鸟鱼虫背带绣片纹样
An embroidered strap with flower, bird, fish and insect patterns

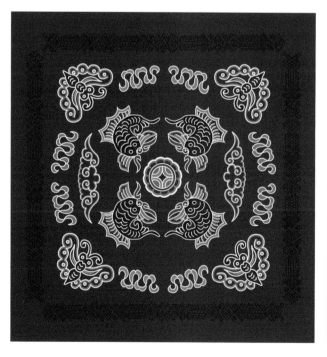

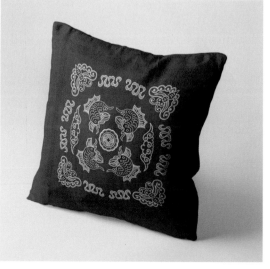

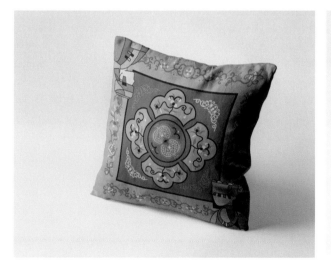

创作手法：计算机软件制图
Creative techniques: computer software drawing

马尾绣纹样提取与创作（水族）
Extraction and design of horsetail embroidery patterns (the Shui ethnic group)

创作手法：计算机软件制图
Creative techniques: computer software drawing

花卉纹样（白族）
Flower patterns (the Bai ethnic group)

　　白族是一个爱花的民族，其头巾、围腰、飘带、背带、草帽带、鞋面等，大多以花草植物为主要装饰。"大理三千户，户户养花"，山茶花、马樱花、杜鹃花、兰花，各种花卉，四季而开。其中茶花品类众多，千姿百态，妙趣横生。这些都为丰富白族花卉纹样做出了贡献。

The Bai people adore flowers so much that their headscarves, waistbands, streamers, straps, straw hat ribbons and shoe uppers are mostly decorated with flower and plant patterns. As a saying goes, "Three thousand households in Dali plant flowers", camellia, lantana, azaleas, orchid and many other flowers bloom in all seasons. Among them, camellia is of many varieties, in various poses and full of fun. All these have contributed to enriching the flower pattern of the Bai people.

创作手法：计算机软件制图
Creative techniques: computer software drawing

仙鹤纹（朝鲜族）
The crane pattern (the Chaoxian ethnic group)

创作手法：计算机软件制图
Creative techniques: computer software drawing

缠枝西番莲纹（藏族）
The interlaced passionflower pattern (the Tibetan ethnic group)

缠枝纹即是同类花纹的统称，在卷草纹、藤蔓纹基础上提炼出来，由于图案中的枝叶呈波浪形，因此被称为"缠枝纹"，包含生生不息、连绵不断之意。该类纹样主要出自汉代瓷器中，盛行于元代，有十分广泛的应用领域。

西番莲纹原本出自西欧的装饰艺术纹样，在明朝传入中国到清朝盛行，在家具雕刻艺术中应用较多。西方西番莲纹的地位相当于中国的牡丹纹，自传入中国后，形式灵活多变，在中国的应用甚至超过了牡丹纹。"缠枝西番莲"，出自西藏传统仲丝工艺，其中缠枝西番莲棱角的造型明显具有仲丝图案手工缝制的特点。

Refined on the basis of "curling grass" and "vines", the interlace pattern is the general name of similar patterns. It is named the "interlace pattern" because the branches and leaves in the pattern are wavy, which means endlessness and continuousness. Such textures mainly came from the porcelain of the Han Dynasty, they became popular in the Yuan Dynasty and had a very wide range of applications.

The passionflower pattern which originally came from the decorative art patterns of Western Europe was introduced to China after the Ming Dynasty and became popular in the Qing Dynasty. It was widely used in the art of furniture carving. The status of the western passionflower pattern was equivalent to the Chinese peony pattern, but since it was introduced to China, its form has been flexible and changeable, and its application in China has even exceeded that of the peony pattern.

创作手法：计算机软件制图
Creative techniques: computer software drawing

宝相花朵云纹（藏族）
The Baoxiang flower cloud pattern (the Tibetan ethnic group)

宝相花伴随印度佛教传入中国，主体为牡丹、莲花，花蕊、花基部分有宝珠。

朵云纹在战国至魏晋时期的瓦片上比较流行。后盛行于隋唐时期，蕴含高升如意之意，广泛应用于古代丝织品之中。

藏族仲丝样式中即包含缠枝西番莲格式，寓意圣洁、端庄、美观，宝相花与朵云纹相结合构成四方连续图案，二者寓意相得益彰，传达了藏族同胞对太平祥和美好生活的向往。

Po-phase flower was introduced to China with India's Buddhism. The main body is composed of peony and lotus, with precious beads on the stamens and flower bases.

The cloud pattern was more popular on tiles from the Warring States Period to the Wei Dynasty, and later prevailed in the Sui and Tang Dynasties. Representing the meaning of promotion and wishful thinking, the pattern was widely used in ancient silk fabrics.

The Tibetan rug designs include the interlaced passionflower pattern, implying holiness, dignity and beauty. The combination of the Po-phase flowers and cloud patterns forms a continuous design in four directions while the two patterns' meanings complement each other to convey the Tibetan compatriots' yearning for a peaceful and harmonious life.

浪花式（开勒昆）地毯纹饰（维吾尔族）
A carpet with the wave pattern (the Uygur ethnic group)

维吾尔族地毯十分注意将同类色或对比色并置排列，在对比中充分显示各种色彩的个性。主要纹样有开力肯（四瓣花纺）、卡其曼（散花图案）、阿娜古丽（石榴图案）、拜西其切克古丽（五枝花图案）、夏米努斯卡（麦加式图案）、博古图案（仿古图案）等。

Uyghur carpets pay great attention to the juxtaposition of similar colors or contrasting colors to fully show the individuality of various colors in contrast. The main patterns are Kailiken (the four-petal flower pattern), Kaqiman (the scattered flower pattern), Anaguli (the pomegranate pattern), Baixiqiqiekeguli (the five-flower pattern), Xiaminusika (the mecca pattern) and Bogu pattern (the antique pattern).

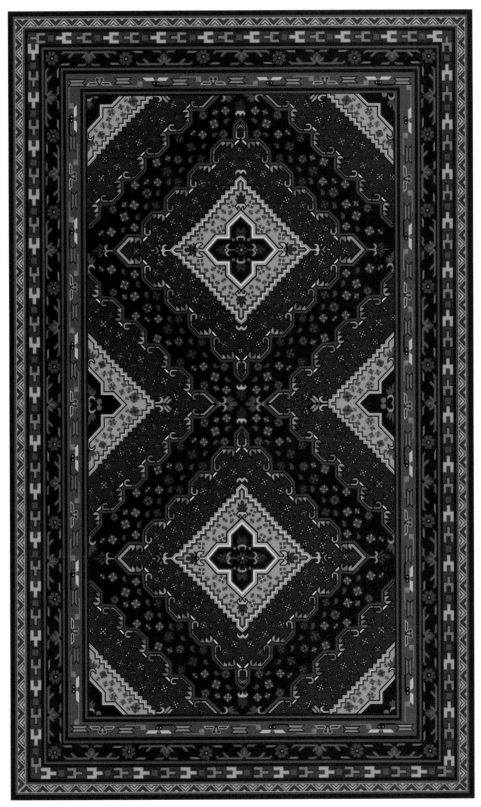

创作手法：计算机软件制图
Creative techniques: computer software drawing

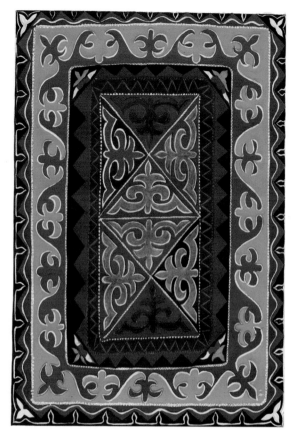

创作手法：铅笔、水粉手绘
Creative techniques: pencil
and poster color hand-painting

毡毯（哈萨克族）
The felt rug (the Kazakh ethnic group)

哈萨克族绣花毡毯纹饰构成形式多样，有对称式、平衡式、均衡式及四方连续等，纹饰和色彩在对比中求变化，浓艳鲜明，成互补色关系，视觉效果强烈。图案中心多为单独或四方连续的植物纹样，四周以三角形等几何形围合，外层是连续的花纹。在方圆和三角形之间找到形式的互补与和谐，图案中三角形纹样有锯齿形、牙齿形，这是对山脉的写实；四周的植物纹样是对野草、花、树木的概括。

The patterns of Kazakh embroidered felt rugs have various forms, such as symmetry, balancedness, proportionality and continuousness in four directions. The bright and vivid patterns and colors are varied in contrast, forming a complementary color relationship and a strong visual effect. The center of the patterns is mostly a single or continuous plant pattern in four directions, surrounded by triangles and other geometric shapes, and the outer layer is continuous patterns.Complementary and harmonious forms are realized among squares, circles and triangles. The triangle pattern containing zigzag and tooth shapes is a realistic representation of mountains, and the surrounding plant pattern a generalization of weeds, flowers and trees.

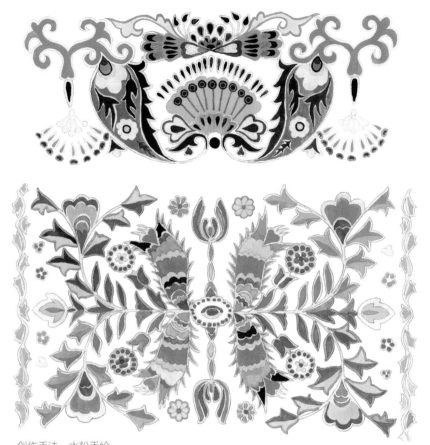

创作手法：水粉手绘
Creative techniques: poster color hand-painting

箱套饰纹（哈萨克族）
The box cover pattern (the Kazakh ethnic group)

　　哈萨克族纹样中大量运用具有动感的曲线，表现出他们对自由的精神追求。在色彩的选择上，以亮色为主，暗色为辅，主要运用蓝色、黄色、红色、绿色、黑色和白色等。植物纹样早期是枣椰树叶纹，后来又出现弯曲茎蔓的葡萄纹，后来变异为波浪曲线几何纹。

　　哈萨克族纹样既是其先民对自然的观察感悟，同时也是对大自然生生不息生命力的表达。

A large number of dynamic curves are used in the Kazakh patterns to show their spiritual pursuit of freedom. In the choice of colors, bright colors are the mainstay, dark colors are supplemented, and blue, yellow, red, green, black and white are mostly used. The early plant pattern was date palm leaf pattern, then the pattern of curved grapevines appeared, and later it was transformed into wavy curve geometric pattern.

The artistic feature of the Kazakh pattern is from the observation and perception of nature by the ancestors, as well as the expression of nature's endless vitality.

创作手法：计算机软件制图
Creative techniques: computer software drawing

萨满神裙飘带（锡伯族）
Shaman dress streamers (the Xibe ethnic group)

　　锡伯族萨满神裙飘带上镶嵌着各种花卉纹理、奇珍异兽、菱角图形，色调和谐，线条统一，肌理清晰。并绣有"万""福"等吉祥图案，每一个图案都寄托着对美好生活的向往，为锡伯族人带来祥和与安康。

The Shaman dress streamers are inlaid with various flower textures, exotic animals and water chestnut graphics in harmonious tones, unified lines and clear texture. The embroidered auspicious patterns such as the "swastika" and "good fortune" embody the yearning for a better life and bring peace and well-being to the Xibe people.

创作手法：计算机软件制图
Creative techniques: computer software drawing

花鸟纹刺绣绣片（锡伯族）
Embroidery pieces with flower and bird patterns (the Xibe ethnic group)

　　锡伯族刺绣纹样质朴原始、自然流畅，是锡伯族人对生命与自然的情感流露。纹样的题材大多来自现实生活，寓意吉祥如意，如桃花、牡丹、鱼、蝙蝠、云、草木等图案，这些图案常见于墙围布、枕套、荷包、嫁妆、葬服等。其中以牡丹、莲花、蝙蝠纹样居多。

The Xibe people's embroidery patterns are simple and primitive, natural and smooth, expressing Xibe people's feelings for life and nature. Most of the pattern themes come from real life with the implication of auspiciousness, such as peach blossoms, peonies, fish, bats, clouds and grass. These designs are commonly seen on wall coverings, pillow ends, purses, dowries and funeral clothing. Among them, peonies, lotuses and bats are widely used.

CHAPTER 2
AUSPICIOUS ANIMALS AND
DRAGON AND PHOENIX PATTERNS

第二章 | 吉祥神兽与龙凤纹样 |

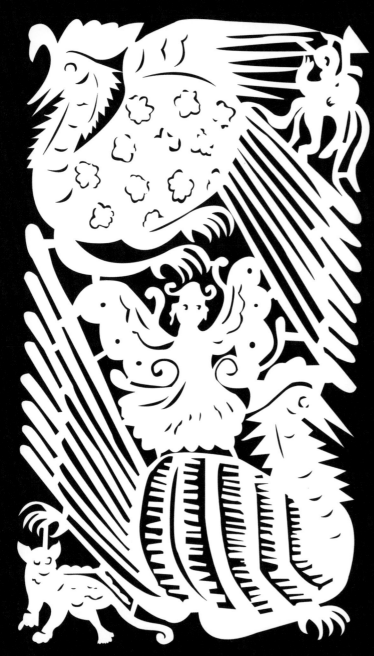

创作手法：计算机软件制图
Creative technique: computer software drawing

剪纸纹饰（苗族）
The paper cutting pattern (the Tibetan ethnic group)

　　左侧剪纸纹样为蝴蝶妈妈。蝶身人面表达了爱情、生殖、生命等文化内涵。

　　右侧剪纸纹样为龙、牛，象征吉祥如意，兴旺发达，与蜡染中的龙纹寓意相似，多子多福，牛勤勤恳恳，勤奋劳作，代表了人对生活最大的理想与追求。

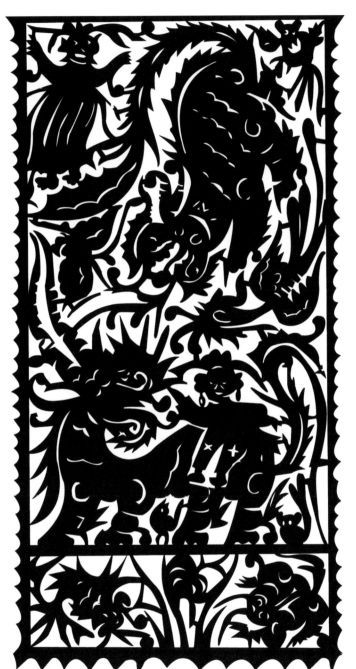

The paper cutting pattern on the left is Mother Butterfly, in which the face of a human and the body of a butterfly connotes love, reproduction and life.

The paper cutting pattern on the right consists of a dragon and a cow, which symbolizes auspiciousness, and flourishing. Like the dragon pattern on a batik cloth, the dragon here means more children for greater happiness while the diligent cow represents hard work. This pattern in its entirety expresses the human's utmost ideal and pursuit of life.

创作手法：计算机软件制图
Creative techniques: computer software drawing

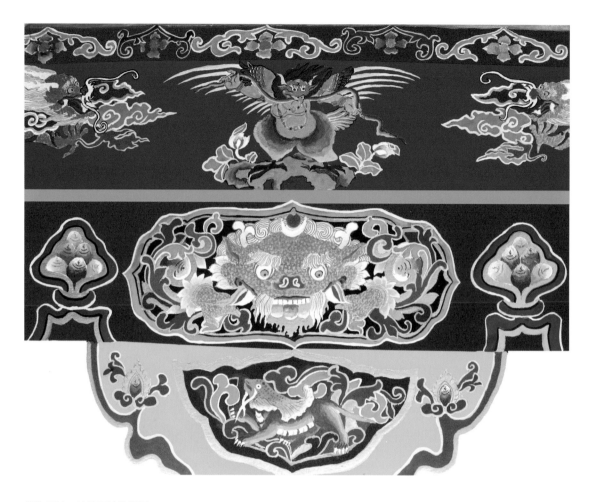

创作手法：计算机软件制图
Creative technique: computer software drawing

塌鼻兽纹（藏族）
The flat-nose beast pattern (the Tibetan ethnic group)

塌鼻、怒目、獠牙，形似狸猫的神兽，多作消灾、守护之用，常见于藏族建筑柱头装饰，象征头衔和权力，是富有代表性的藏族纹饰之一。

The pattern of the leopard cat-like beast with a flat nose, angry eyes and canine teeth, is mostly used for getting rid of bad luck and praying for guardianship. As one of the representative Tibetan ornaments, this pattern is often seen in the decoration of capitals in Tibetan architecture symbolizing titles and powers.

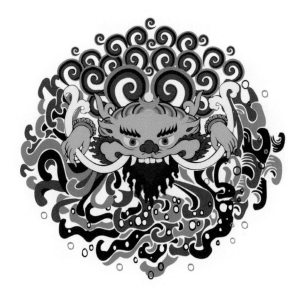
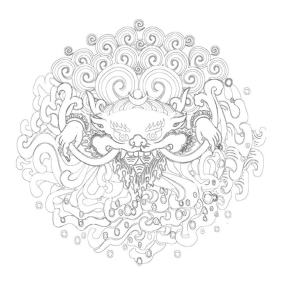

创作手法：计算机软件制图
Creative techniques: computer software drawing

塌鼻兽纹样创新设计（藏族）
Innovative design of the flat-nose beast patterns (the Tibetan ethnic group)

创作手法：彩色铅笔手绘
Creative techniques: color pencil drawing

渡河公（壮族）
Duhegong (the Zhuang ethnic group)

渡河公取自传说，经过历代演变，原本无脸、黑头、无辫、四肢抱南瓜形象添加了憨态可掬的笑、精巧的辫子等更多人的形象，寄托思念祖先的心愿，祈祷未来风调雨顺、富足安康。

农历五月初五端午节，是中国最大的传统节日之一，广西上林的三里镇一带，家家户户齐聚清清的小河边欢度当地的民间民俗活动"渡河公"节，该民俗形成于明朝，至今有四百年的历史。每年五月初五端午节傍晚，在清水河畔，村里的男女老少一边吟咏祈祷词，一边把做好的"渡河公"用红或黄丝线挂在小孩的脖子上。人们也会把"渡河公"和粽子放在一艘小船上，点上红蜡烛，使其沿河漂流，让点点河灯带走岁月的不幸和忧伤。

Duhegong is taken from a legend and has evolved through the ages from the image of facelessness, blackhead, no braids, and holding a pumpkin with arms and legs to a human image with a naive smile and delicate braids. It conveys the Zhuang people's missing of their ancestors and wishes for safety and happiness.

The Dragon Boat Festival on the fifth day of the fifth month of the lunar calendar is one of China's well-known traditional festivals. In the Sanli Town of Shanglin, Guangxi, families gather along the riverside to celebrate the local folklore activity "Duhegong". The folk custom was formed in the Ming Dynasty and has a history of four hundred years. On the evening of the Dragon Boat Festival every year, the villagers chant prayers while hanging the finished "Duhegong" around the children's neck with red or yellow silk threads,. "Duhegong" are also placed with Zongzi on a small boat, with lit red candles, and the boat floats along the river, so that the flickering candlelight takes away the misfortune and sadness of the year.

创作手法：计算机软件制图
Creative techniques: computer software drawing

"都盘修曲" 神鸟图案创作（纳西族）
"Dupan Xiuqu" Divine Bird Pattern Creation （the Naxi ethnic group）

都盘修曲是纳西族东巴神话中的大鹏神鸟，亦被当地人称作保护神。

Dupan Xiuqu is the divine bird named Dapeng in Dongba mythology of Naxi ethnic group, and is also called the guardian god by the local people.

创作手法：计算机软件制图
Creative techniques: computer software drawing

狩猎纹创新设计（锡伯族）
Innovative design of the hunting pattern (the Xibe ethnic group)

　　狗是锡伯族人民生产劳动中的忠实伙伴，平时它看门望户，防止盗贼窜入；当孩子们进山时，它能保护小主人的安全；当放牧时，几条猎狗可保护上百只的羊群。锡伯族人通过对自然的观察，提炼构成了锡伯族独特的动植物纹样，通过大胆想象，使之更加生动精美，用拟物化手法，将花草变得像鸟虫，又把鸟虫变得像花草，出神入化，实用与欣赏融为一体。[1]

Dogs are loyal partners of the Xibe people. They usually serve as guardians for the Xibe households to prevent thieves from entering; the Xibe people avoid eating dog meat and ban the use of dog skins; dogs also protect children from danger in the mountains, and a few hunting dogs can protect hundreds of sheep during grazing;The Xibe people formed their unique animal and plant patterns by observing and refining natural objects, and made them more vivid and exquisite through bold imagination. They turned flowers and plants into birds and insects and the other way round with the technique of simulative materialization, so that the superb patterns are both practical and admirable.

1　贺灵 . 新疆锡伯族工艺美术史 [M]. 新疆美术摄影出版社，2015：72.

锡伯族哈儿纹样及其变化
The Xibe people's Haer patterns
and their changes

创作手法：计算机软件制图
Creative techniques: computer software drawing

植物纹与鹿纹（锡伯族）
The plant pattern and deer pattern (the Xibe ethnic group)

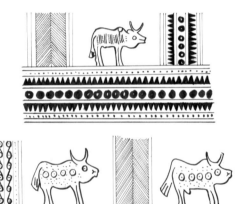

铜鼓纹 (壮族)
The bronze drum pattern (the Zhuang ethnic group)

　　铜鼓，金石之声，铿锵沉郁，寄托着古壮人的思想感情、宇宙观念、生活习俗和人生理想，是壮族文化的历史见证和"活化石"。铜鼓物像纹饰有太阳纹、翔鹭纹、蛙纹、鹿纹、龙舟竞渡纹和羽人舞蹈纹等；图案纹饰有云雷纹、圆圈纹、钱纹和席纹等。

Bronze drums, as the historical testimony and "living fossil" of the Zhuang culture, convey the ancient Zhuang people's thoughts and feelings, their concepts of the universe and their life customs and ideals. The bronze drums' object patterns include the sun, flying heron, frog, deer, racing dragon boat and dancing feathered fairy. The design patterns include the cloud and thunder, circle, copper money and mat.

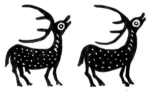

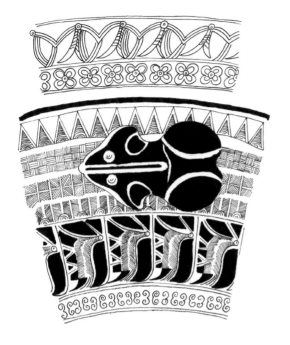

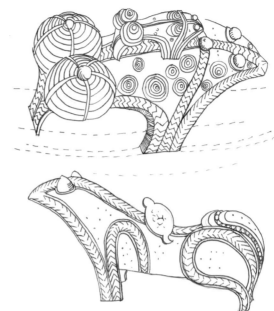

蛙纹（壮族）
The frog pattern (the Zhuang ethnic group)

壮族传说，青蛙是雷神的儿子。因此，壮族人对蛙敬若神明。

According to the Zhuang people's myth, frogs are sons of the God of Thunder. Therefore, the Zhuang people respect frogs like gods.

翔鹭纹（壮族）
Flying heron patterns (the Zhuang ethnic group)

翔鹭纹是铜鼓装饰艺术中重要的动物纹饰，普遍存在于石寨山型铜鼓中。翔鹭纹大多都是写实的，有着长长的嘴，有的下方还有食囊。翔鹭纹的飞翔姿态十分优美，栩栩如生。

As the important animal patterns in the decorative art of bronze drums, the flying heron patterns are commonly seen on the Shizhaishan-type bronze drums. Most of the flying heron patterns are realistic, with long beaks, and some even have food pouches below. The flying heron patterns are beautiful in shapes and have the tendency of flying.

创作手法：计算机软件制图
Creative techniques: computer software drawing

铜鼓纹样创新设计（壮族）
Innovative design of bronze drum patterns (the Zhuang ethnic group)

创作手法：计算机软件制图
Creative techniques: computer software drawing

铜鼓纹样创新设计（壮族）
Innovative design of bronze drum patterns (the Zhuang ethnic group)

创作手法：铅笔手绘
Creative technique: pencil drawing

马尾绣口水垫（水族）
A horsetail embroidery bib (the Shui ethnic group)

　　水族马尾绣中对花草纹有广泛的应用，充分体现了水族人民对大自然的热爱和尊崇。凤鸟纹在马尾绣中也被频繁使用。根据《中国民间歌曲集成·贵州卷》的记述，"水族对各类禽鸟有着深厚的感情，诸如画眉、阳雀、布谷等，在他们的歌唱中屡见不鲜，而这种对鸟类的钟爱被理想化在'凤凰'身上"。水族称凤凰为"长命鸟""大翅羽"，与马尾绣中凤凰纹的内涵相映衬，在服饰上绣"长命鸟"，可以保佑长命百岁，幸福安康。

The plant patterns are widely used in the Shui horsetail embroidery to express the Shui people's respect for animals and love for plants, and reflect their natural cognition that all things breed and foster mutually.

The phoenix patterns are also widely used the horsetail embroidery. According to the Collection of Chinese Folk Songs(Guizhou Volume), "the Shui people have a deep affection for all kinds of birds, such as thrushes, sunbirds, cuckoos, etc., which are common in their singing, and this love for birds is inadvertently idealized in 'Phoenix'". The phoenix is referred to as the "Longevity Bird" and "Large Wing Feather" by the Shui people, which contrasts with the connotation of the phoenix patterns in the horsetail embroidery. The Shui people believe that embroidering the "Longevity Bird" on clothes can bless the wearers with longevity, health and safety.

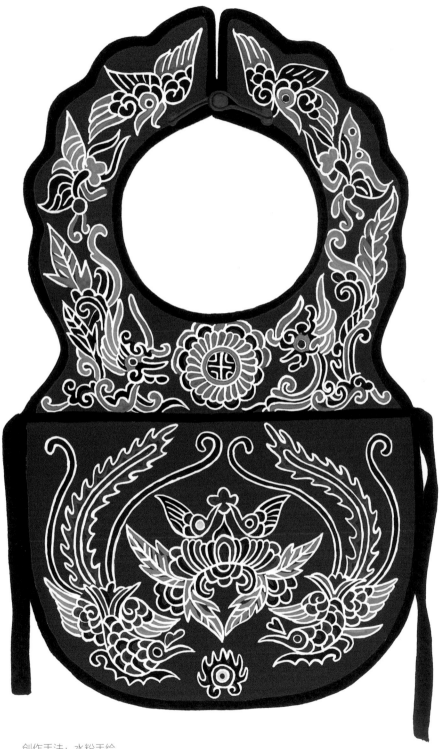

创作手法：水粉手绘
Creative techniques: poster color hand-painting

创作手法：铅笔手绘
Creative techniques: pencil drawing

凤凰纹、如意纹鞋垫（水族）
Insoles with phoenix and Ruyi patterns（the Shui ethnic group）

凤凰纹：水族称凤凰为"长命鸟""大翅羽"，恰巧代表凤凰纹的文化内涵和审美特征。传说古时候是凤凰带水族人找到了水。作为水族人心中一切美好和吉祥的象征，凤凰成为马尾绣传承的重要纹样。

如意纹：类似银锭、寿石、礼器之类的器物，如意本有"吉祥"寓意，其纹样表达了人们追求的各种美好愿望，以至于图必有意，意必吉祥。

The Phoenix pattern: the Shui people call the phoenix the "Longevity Bird" and "Large Wing Feather", which exactly represents the cultural connotation and aesthetic characteristics of the phoenix pattern. The legend has it that in ancient times, it was the Phoenix who led the Shui people to water. As a symbol of all goodness and auspiciousness in the hearts of the Shui people, the phoenix has become an important pattern in the inheritance of horsetail embroidery.

The Ruyi pattern: like silver bullions, shoushi (a stone symbolizing longerity) and ritual vessels, Ruyi itself means "auspiciousness", and the pattern expresses all kinds of good wishes that people pursue, so that the pattern must be allegorical and the allegory must be auspicious.

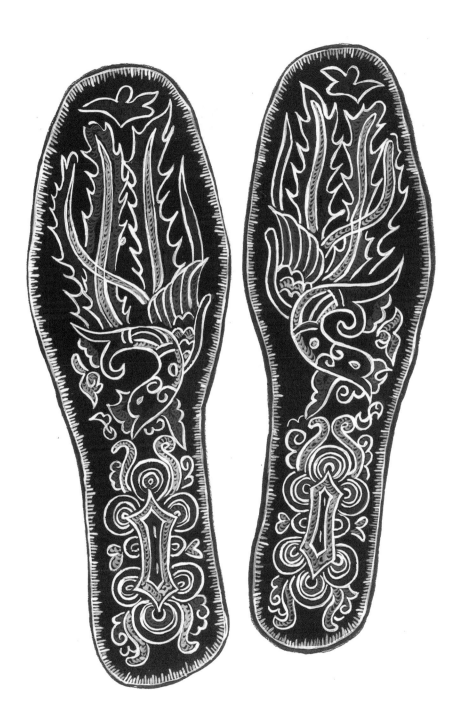

创作手法：水粉手绘
Creative techniques: poster color hand-painting

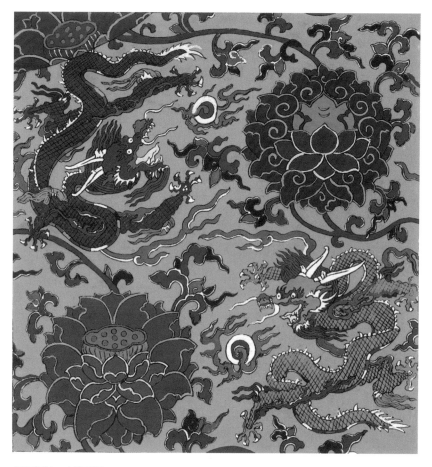

创作手法：水粉手绘
Creative techniques: poster color hand-painting

龙纹男袍局部（藏族）
A part of men's robe with the dragon pattern (the Tibetan ethnic group)

　　此图案为乾隆时期之后的藏族服饰。其龙纹造型慈祥、和睦、安宁。对藏族人民而言象征吉祥与守护，表达其对美好生活的向往。

This image is a Tibetan civilian's clothes design after the reign of the Emperor Qianlong of the Qing Dynasty. The Tibetan dragon patterns were of kind, harmonious and tranquil style, which, to the Tibetans, meant good luck and guardianship, expressing their yearning for a better life.

创作手法：铅笔手绘
Creative techniques: pencil drawing

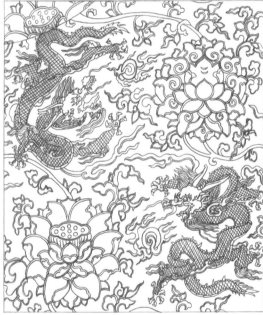

穿花龙纹
The Dragon Wearing Flower

　　"穿花龙纹"又称"花间龙纹""龙穿花纹""串花龙纹"，龙行花间，锦绣吉祥，惬意安宁。除了服饰，此纹样多见于明朝瓷器，花朵略有不同。

The pattern Dragon Wearing Flower, which is also known as Dragon among Flowers and Dragon through Flowers, depicts a dragon flying through flowers, which symbolizes glory and auspiciousness as well as pleasure and peace. In addition to clothes, this pattern is mostly seen on ceramics of the Ming Dynasty with slightly different flowers.

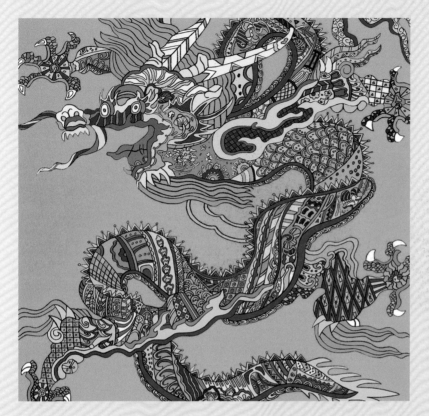

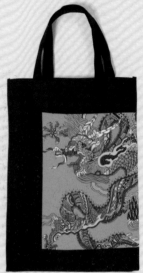

创作手法：计算机软件制图
Creative techniques: computer software drawing

龙纹创新设计（藏族）
Innovative design of the dragon pattern (the Tibetan ethnic group)

　　藏族图案中的龙元素十分可亲，腾空时张牙舞爪的模样带几分憨态，因此在产品应用上空间更广、更亲民。将这一外形与现代图形元素结合，龙的形象充满张力和现代感，再配以橘黄底色，即刻跃然而起，具有较强的视觉冲击力。

The dragon element in the Tibetan patterns is very amiable, and its teeth and claws look cute as it takes off. Therefore, the product is more popular and widely used. Combining the shape with modern graphic elements, the dragon image is full of tension and modernity. Coupled with an orange-yellow background, the pattern brings about a strong visual impact as if the dragon instantly rises.

创作手法：计算机软件制图
Creative techniques: computer software drawing

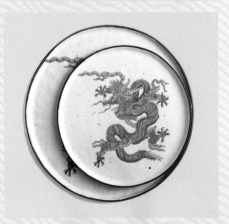

创作手法：计算机软件制图
Creative techniques: computer software drawing

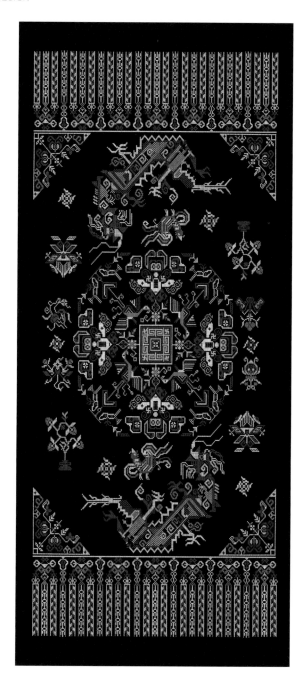

头巾（彝族）[1]

A headscarf (the Yi ethnic group)

　　此款挑花头巾，图案由龙凤、蝴蝶、花草及几何纹样组合而成。此款绣品中的龙纹样非常精美，用极简的线条最大限度地表现了龙纹的丰富细节，严谨有序且生动活泼。

The design of this cross-stitch headscarf is a combination of the dragon and phoenix pattern, butterfly pattern, flower and grass patterns and geometric pattern. The dragon pattern in this embroidery is very exquisite, with simple lines to maximize its rich details, making it rigorous, orderly and lively.

1　实物来自贵州省毕节市威宁县。

创作手法：计算机软件制图
Creative techniques: computer software drawing

蝴蝶纹、龙纹创新设计
Innovative design of butterfly and dragon patterns

创作手法：彩色铅笔手绘
Creative techniques: color
pencil drawing

邹绣绣片（苗族）[1]

A piece of embroidery with the wrinkling stitch (the Miao ethnic group)

苗族刺绣中的龙纹没有特定的形状和模式，有鱼龙、鸟龙、蜈蚣龙、蛇龙等，此款绣片纹样为邹绣"双头龙"，龙纹两边对称饰有变体凤纹，整个纹样色泽鲜明、粗犷浑厚、具有很强的立体感和肌理效果。

The dragon patterns are designed freely, including variations of ichthyosaur, rhamphorhynchus, and snakes. The pattern on this piece of embroidery is Two Heads Dragon with symmetrical phoenix patterns around, and bright, bold and vivid colors.

1 实物来自贵州省黔东南州雷山县。

创作手法：彩色铅笔手绘
Creative techniques: color pencil drawing

背带绣片（苗族）¹
An embroidered strap (the Miao ethnic group)

1 实物来自贵州省黔东南州台江县。

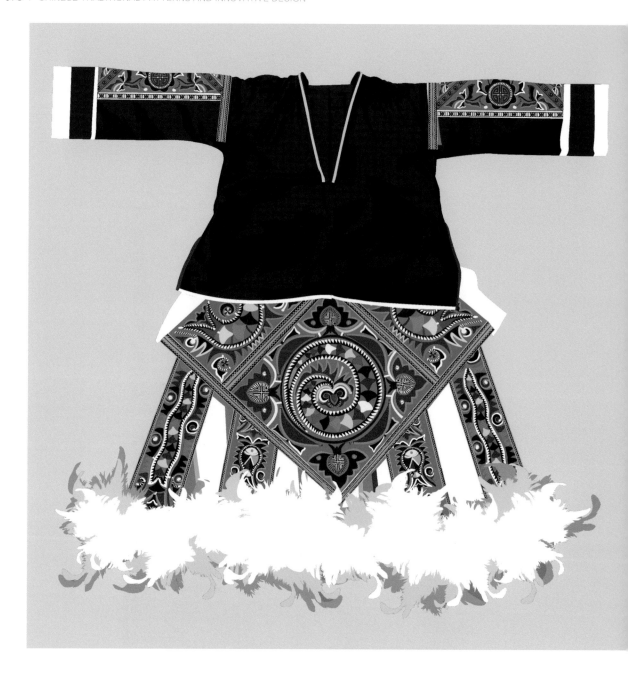

百鸟衣（苗族）
Hundred-bird embroidered costume (the Miao ethnic group)

　　这是贵州省黔东南苗族侗族自治州丹寨县雅灰乡的女盛装—百鸟衣。苗族百鸟衣可溯源到苗族远古时代的古史神话"蝴蝶妈妈"的传说，苗族把鸟作为始祖来崇拜，在苗族祭祖活动的"鼓藏节"上，主祭服就是百鸟衣。整件衣服上用五彩丝线绣出各种造型的纹样，纹样类型包括鸟龙、牛龙、蛇龙、太阳、圆形圈龙、枫叶、蝴蝶、异形动物等纹样。衣脚装饰有一束束鸟的羽毛，造型独特且原始古朴，被誉为"穿在身上的苗族史诗"。

　　此件百鸟衣上的主要装饰纹样就是一条盘旋的龙蛇纹。在苗族的很多刺绣、蜡染作品里都可见到这种龙蛇纹，它是古老的河图符形的演变。

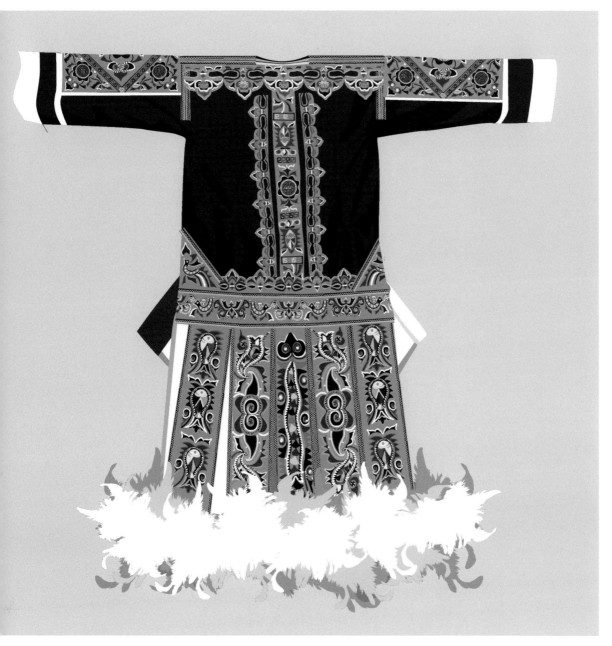

创作手法：计算机软件制图
Creative techniques: computer software drawing

Hundred-bird embroidered costumes have a long history in the Miao ethnic group, which can be traced back to the myth of the Mother Butterfly. Birds are worshiped as the ancestor by the Miao peopleand hunderdred-bird embroidered costumes are attired in on the Guzang festival. This simple and unique costume is embroidered with various patterns including the sun, circle, maple leaf, butterfly and animal, and purfled with feathersand thus is crowned "the wearable epic for the Miao ethnic group".

The main decorative element on this costume is a spiral dragon snake pattern,evolved from the ancient river pattern,which can be seen in many Miao embroidery and batik works.

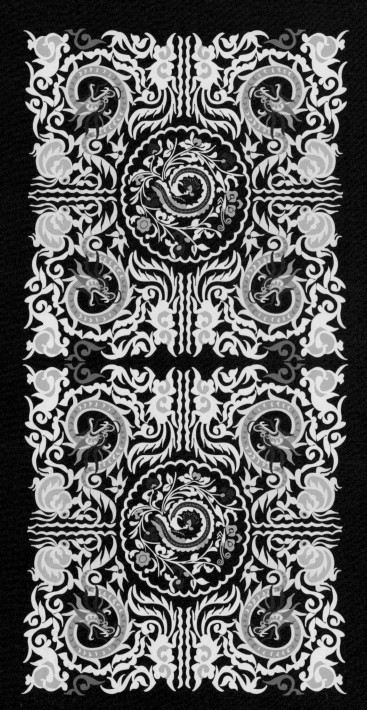

创作手法：计算机软件制图
Creative techniques: computer software drawing

龙纹图案提取与创作
Dragon pattern extraction and design

创作手法：计算机软件制图
Creative techniques: computer software drawing

CHAPTER 3
CHARACTER SYMBOLS
AND HUMAN FIGURES

第三章 | 文字符号与人物纹样 |

方胜纹
The Fang-Sheng pattern

回纹
The fret pattern

犄纹
The horn pattern

哈木尔纹
The hamuer pattern

创作手法：计算机软件制图
Creative techniques: computer software drawing

哈敦绥格纹、回纹、犄纹、哈木尔纹（蒙古族）
The hadunsuige pattern, fret pattern, horn pattern, hamuer pattern (the Mongolian ethnic group)

哈敦绥格纹（方胜纹）：吉祥图案的一种，绥格就是"胜"，胜是指妇女的首饰。哈敦绥格是两个菱形压角相叠形成的图案，一方面取"胜"的吉祥意义，寓意"优胜"；另一方面取其形的压角相叠，寓意"同心"。

回纹：象征吉祥、坚强。连续的回旋形线条构成几何图形，广泛应用于毡绣、地毯、建筑装饰、盘碗器物及袖口、领口等。

犄纹：犄纹图案多以二方连续和边缘图案的形式出现，常见于牧民缝制的毡绣和刺绣中，寓意五畜兴旺、牧业丰收。

哈木尔纹（牛鼻纹）：蒙语"哈木尔"是"鼻子"的意思，哈木尔纹则是对牛鼻造型的模仿。造型简单大方，总框架下两条曲线变化随意，寓意吉祥的祝愿。

The Hadunsuige pattern (Fang-Sheng pattern): The Hadunsuige pattern is one of the auspicious patterns. Suige refers to "Sheng", women's jewelry. Hadunsuige is a pattern formed by two rhombuses with overlapping angles. The pattern takes the auspicious meaning of "Sheng", namely, "victory"; the overlapping angles of the shape means "teamwork".

The fret pattern: Symbolizing auspiciousness and strength. the geometric shapes formed by continuous convoluted lines are widely used in felt embroidery, carpets, architectural decoration, dishes, cuffs and necklines.

The horn pattern: The horn pattern often appears in the form of continuous design in two directions and edge design, and is commonly used on felt embroidery and embroidery made by herdsmen, implying livestock prosperity and good harvest.

The Hamuer pattern (cow nose pattern): "Hamuer" means nose in Mongolian language, and Hamuer pattern is an imitation of the shape of a cow's nose. The pattern is simple and generous, and the two curves under the general frame change at will, implying auspicious wishes.

方胜缠枝纹
The Fang-Sheng interlace pattern

兰萨纹
The Lansa pattern

寿字纹
The "Shou" pattern

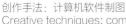

创作手法：计算机软件制图
Creative techniques: computer software drawing

蒙古族服装纹样提取
Extraction of patterns from Mongolian clothing

蒙古族纹样
The Mongolian patterns

　　兰萨图案通常会与盘肠纹、卷草纹组合应用，寓意天地相同、阴阳相合、生命延续。

Lansa design is often used in combination with Panchang and curly grass patterns. It is a symbol of eternal life and conveys the meanings of the uniting of heaven and earth, the harmony of yin and yang, and the continuation of all generations.

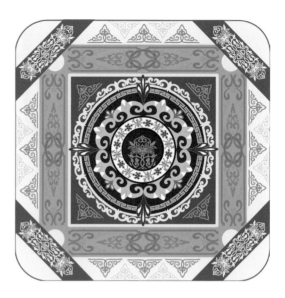

创作手法：计算机软件制图
Creative techniques: computer software drawing

蒙古族纹样创作
Design of the Mongolian patterns

创作手法：计算机软件制图
Creative techniques: computer software drawing

创作手法：计算机软件制图
Creative techniques: computer software drawing

蒙古族纹样创作
Design of the Mongolian patterns

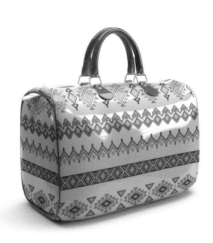

蒙古族纹样创作
Design of the Mongolian patterns

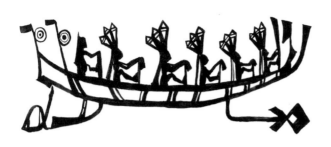

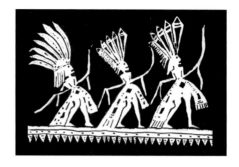

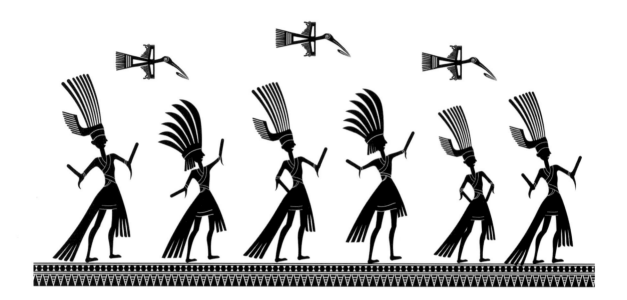

人物纹（壮族）
The human figure pattern (the Zhuang ethnic group)

人物纹寓意人丁兴旺，还用于记录日常生活的场景，如羽人舞蹈图、牛耕图、龙舟图等纹样，常见于壮族铜鼓之上。

The human figure pattern, implying human prosperity, is also used to record scenes of everyday life, such as the dancing feathered fairies, farming cattle and dragon boats, which is often seen on the Zhuang people's bronze drums.

羽人舞蹈图（壮族）
Dancing feathered fairy design (the Zhuang ethnic group)

羽人者头戴羽冠，身披羽饰，手舞足蹈。现实生活中，壮族人常化装成鸷鸟模样，舞蹈作乐，或一两人，或十余人。

The dancing feathered fairies are dressed in feather crowns and feather ornaments. In real life, the Zhuang people often make up as birds of prey, and dance and have fun, alone or in a pair or with a dozen of others.

创作手法：计算机软件制图
Creative techniques: computer software drawing

羽人纹样创新设计（壮族）
Innovative design of feathered fairy patterns (the Zhuang ethnic group)

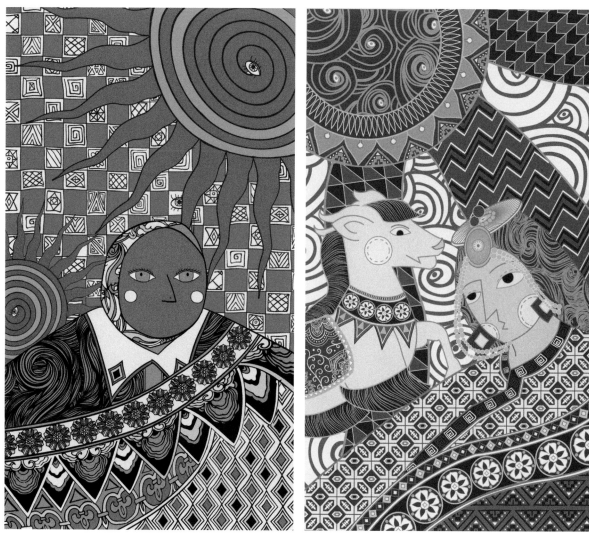

创作手法：计算机软件制图
Creative techniques: computer software drawing

几何人物纹样创新设计（藏族）
Innovative design of geometric human figure patterns (the Tibetan ethnic group)

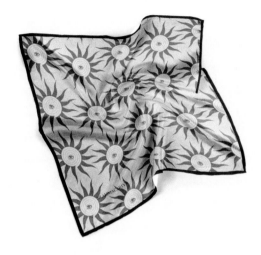

创作手法：计算机软件制图
Creative techniques: computer software drawing

藏族纹样创新设计
Innovative design of the Tibetan patterns

创作手法：计算机软件制图
Creative techniques: computer software drawing

藏族纹样创新设计
Innovative design of the Tibetan patterns

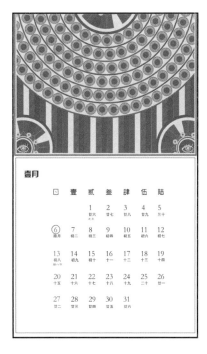

壹月

日	壹	贰	叁	肆	伍	陆		
				1 廿六	2 廿七	3 廿八	4 廿九	5 三十
⑥ 腊月	7 初二	8 初三	9 初四	10 初五	11 初六	12 初七		
13 初八	14 初九	15 初十	16 十一	17 十二	18 十三	19 十四		
20 十五	21 十六	22 十七	23 十八	24 十九	25 二十	26 廿一		
27 廿二	28 廿三	29 廿四	30 廿五	31 廿六				

贰月

日	壹	贰	叁	肆	伍	陆
					1 廿七	2 廿八
3 廿九	4 三十	⑤ 正月	6 初二	7 初三	8 初四	9 初五
10 初六	11 初七	12 初八	13 初九	14 初十	15 十一	16 十二
17 十三	18 十四	19 十五	20 十六	21 十七	22 十八	23 十九
24 二十	25 廿一	26 廿二	27 廿三	28 廿四		

叁月

日	壹	贰	叁	肆	伍	陆
					1 廿五	2 廿六
3 廿七	4 廿八	5 廿九	6 三十	⑦ 正月	8 初二	9 初三
10 初四	11 初五	12 初六	13 初七	14 初八	15 初九	16 初十
17 十一	18 十二	19 十三	20 十四	21 十五	22 十六	23 十七
24 十八	25 十九	26 二十	27 廿一	28 廿二	29 廿三	30 廿四

肆月

日	壹	贰	叁	肆	伍	陆
	1 廿六	2 廿七	3 廿八	4 廿九	⑤ 三月	6 初二
7 初三	8 初四	9 初五	10 初六	11 初七	12 初八	13 初九
14 初十	15 十一	16 十二	17 十三	18 十四	19 十五	20 十六
21 十七	22 十八	23 十九	24 二十	25 廿一	26 廿二	27 廿三
28 廿四	29 廿五	30 廿六				

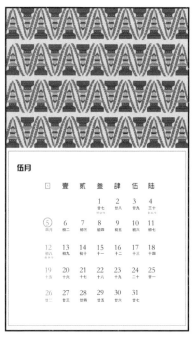

伍月

日	壹	贰	叁	肆	伍	陆
			1 廿七	2 廿八	3 廿九	4 三十
⑤ 四月	6 初二	7 初三	8 初四	9 初五	10 初六	11 初七
12 初八	13 初九	14 初十	15 十一	16 十二	17 十三	18 十四
19 十五	20 十六	21 十七	22 十八	23 十九	24 二十	25 廿一
26 廿二	27 廿三	28 廿四	29 廿五	30 廿六	31 廿七	

陆月

日	壹	贰	叁	肆	伍	陆
						1 廿八
2 廿九	③ 五月	4 初二	5 初三	6 初四	7 初五	8 初六
9 初七	10 初八	11 初九	12 初十	13 十一	14 十二	15 十三
16 十四	17 十五	18 十六	19 十七	20 十八	21 十九	22 二十
23 廿一	24 廿二	25 廿三	26 廿四	27 廿五	28 廿六	29 廿七
30 廿八						

创作手法：计算机软件制图
Creative techniques: computer software drawing

藏族纹样日历设计
Calendar design with the Tibetan patterns

柒月

日	壹	贰	叁	肆	伍	陆		
			1	2	3	4	5	6
			三十	六月	初二	初三	初四	
7	8	9	10	11	12	13		
初五	初六	初七	初八	初九	初十	十一		
14	15	16	17	18	19	20		
十二	十三	十四	十五	十六	十七	十八		
21	22	23	24	25	26	27		
十九	二十	廿一	廿二	廿三	廿四	廿五		
28	29	30	31					
廿六	廿七	廿八	廿九					

捌月

日	壹	贰	叁	肆	伍	陆
				1	2	3
				七月	初二	初三
4	5	6	7	8	9	10
初四	初五	初六	初七	初八	初九	初十
11	12	13	14	15	16	17
十一	十二	十三	十四	十五	十六	十七
18	19	20	21	22	23	24
十八	十九	二十	廿一	廿二	廿三	廿四
25	26	27	28	29	30	31
廿五	廿六	廿七	廿八	廿九	八月	初二

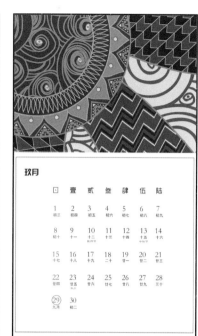

玖月

日	壹	贰	叁	肆	伍	陆
1	2	3	4	5	6	7
初三	初四	初五	初六	初七	初八	初九
8	9	10	11	12	13	14
初十	十一	十二	十三	十四	十五	十六
15	16	17	18	19	20	21
十七	十八	十九	二十	廿一	廿二	廿三
22	23	24	25	26	27	28
廿四	廿五	廿六	廿七	廿八	廿九	三十
29	30					
九月	初二					

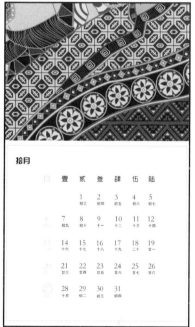

拾月

日	壹	贰	叁	肆	伍	陆	
			1	2	3	4	5
			初三	初四	初五	初六	初七
6	7	8	9	10	11	12	
初八	初九	初十	十一	十二	十三	十四	
13	14	15	16	17	18	19	
	十六	十七	十八	十九	二十	廿一	
20	21	22	23	24	25	26	
	廿三	廿四	廿五	廿六	廿七	廿八	
27	28	29	30	31			
	十月	初二	初三	初四			

拾壹月

日	壹	贰	叁	肆	伍	陆
					1	2
					初五	初六
3	4	5	6	7	8	9
初七	初八	初九	初十	十一	十二	十三
10	11	12	13	14	15	16
十四	十五	十六	十七	十八	十九	二十
17	18	19	20	21	22	23
廿一	廿二	廿三	廿四	廿五	廿六	廿七
24	25	26	27	28	29	30
廿八	廿九	冬月	初二	初三	初四	初五

拾贰月

日	壹	贰	叁	肆	伍	陆
1	2	3	4	5	6	7
初六	初七	初八	初九	初十	十一	十二
8	9	10	11	12	13	14
十三	十四	十五	十六	十七	十八	十九
15	16	17	18	19	20	21
二十	廿一	廿二	廿三	廿四	廿五	廿六
22	23	24	25	26	27	28
廿七	廿八	廿九	三十	腊月	初二	初三
29	30	31				
初四	初五	初六				

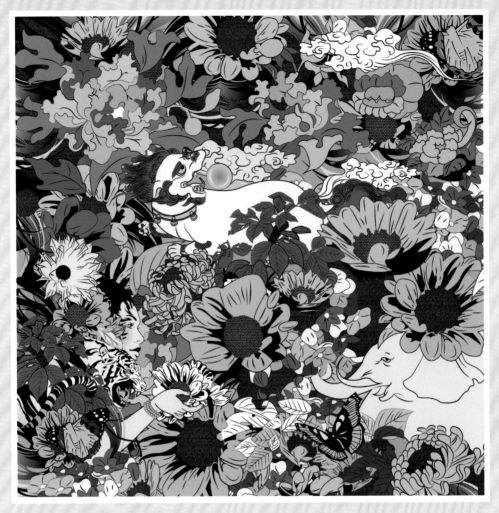

创作手法：计算机软件制图
Creative techniques: computer software drawing

人物与神兽纹样创新设计（藏族）
Innovative design of human figure and animal patterns (the Tibetan ethnic group)

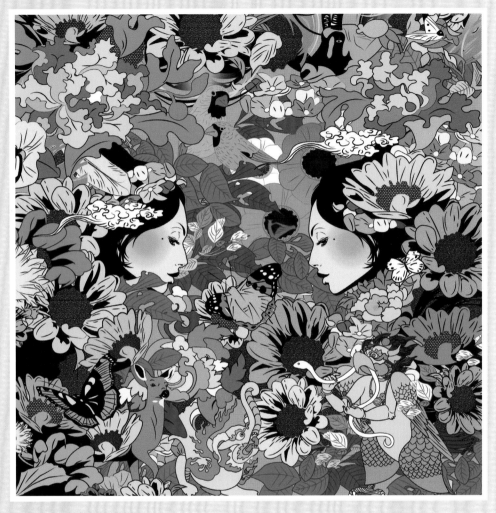

创作手法：计算机软件制图
Creative techniques: computer software drawing

人物与神兽纹样创新设计（藏族）
Innovative design of human figure and animal patterns (the Tibetan ethnic group)

创作手法：计算机软件制图
Creative techniques: computer software drawing

头巾（彝族）[1]
A headscarf (the Yi ethnic group)

　　此款挑花头巾，图案由花鸟鱼虫、人物、八角花等纹样组合而成，红色为主，白色为辅，点缀黄、蓝、绿等对比色，在黑底色上十分醒目。图案样式有独立纹样、角纹样、适合纹样等。

This cross-stitch headscarf exhibits a combination of the flower, bird, fish and insect pattern, human figure pattern and octagon pattern. The main color red is supplemented with the color white and embellished with the contrasting colors of yellow, blue, green, which is very eye-catching on the black background. The design is a combination of independent patterns, horn patterns and suitable patterns.

1　实物来自贵州省毕节市威宁县。

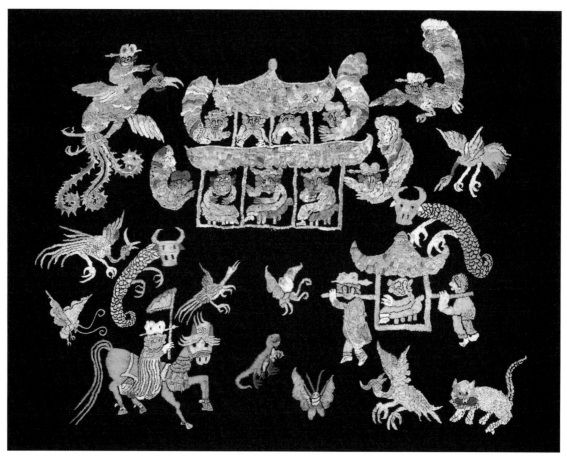

创作手法：计算机软件制图
Creative techniques: computer software drawing

女服局部（苗族）[1]
A part of the women's clothes (the Miao ethnic group)

　　此款女服是平绣与乱针绣相结合制作而成的，图案有人物骑马、人物抬轿、蝴蝶、亭台、龙凤等，构图自由灵活，人物及动物形象憨态可掬，独具特色。

This women's clothes demonstrates a combination of straight stitch and random stitch. The patterns include human figures of riding a horse and carrying a scdan chair, butterflies, pavilions, dragons and phoenixes. The composition is flexible, and the unique images of human figures and animals are charmingly naive.

1 实物来自贵州省黔东南州台江县。

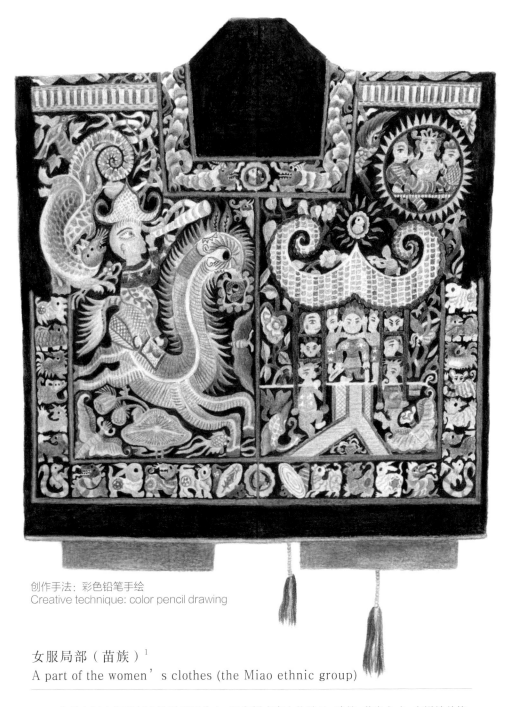

创作手法：彩色铅笔手绘
Creative technique: color pencil drawing

女服局部（苗族）[1]
A part of the women's clothes (the Miao ethnic group)

此款台江女服绣制方法以平绣为主，图案样式有人物骑马、建筑、花鸟鱼虫、吉祥神兽等，构图饱满、色彩搭配以淡紫、蓝绿色系为主，衬以黑底，人物及动物形象生动有趣，独具特色。

This Taijiang women's clothes adopts straight stitch mainly. The patterns include human figures riding a horse, architecture, flowers, birds, fish and insects and auspicious animals. The rich composition adopts lavender and blue-green as the main colors and black as the background. The vivid human figures and animals are interesting and unique.

1 实物来自贵州省黔东南州台江县。

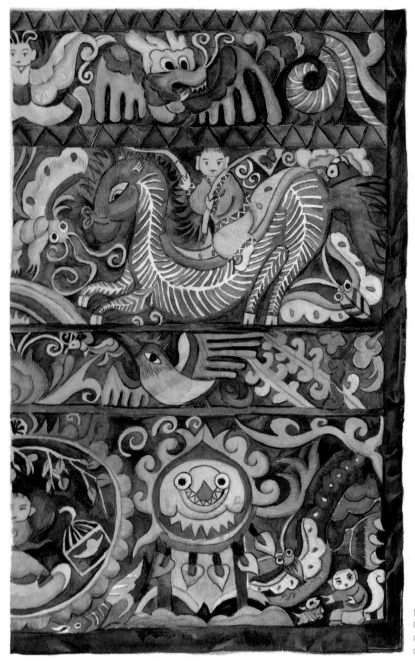

创作手法：彩色铅笔、水粉手绘
Creative techniques:
color pencil and poster
color hand-painting

女服局部（苗族）[1]
A part of the women's clothes (the Miao ethnic group)

此款台江仿古新女服绣制方法为平绣与乱针绣相结合，图案样式有人物骑马、花鸟鱼虫、吉祥神兽等纹样，构图饱满、色彩丰富，人物及动物形象生动诙谐，独具特色。

This new Taijiang women's antique clothes presents a combination of straight stitch and random stitch. The patterns include human figures riding a horse, flowers, birds, fish and insects and auspicious animals. The composition is rich and colorful, and the unique human figures and animal images are vivid and hilarious.

1 实物来自贵州省黔东南州台江县。

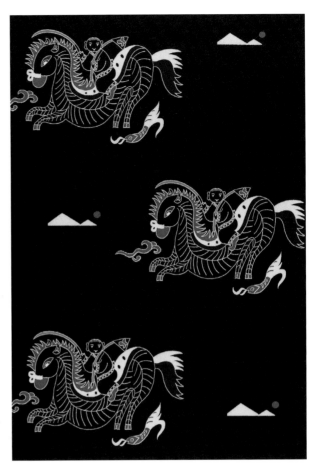

创作手法：计算机软件制图
Creative techniques: computer software drawing

仿古新女服图案创新设计
Innovative design of the women's antique clothes pattern

创作手法：计算机软件制图
Creative techniques: computer software drawing

头巾（彝族）¹

A headscarf (the Yi ethnic group)

　　此款挑花头巾，图案由人物骑马、人物抬轿、花草及八角花等纹样构成，图案样式有独立纹样、角纹样、边饰纹样，大红底色搭配彩色线条，洋溢着喜庆的气息，同时极简的动植物及人物造型具有很强的现代感。

The design of this cross-stitch headscarf includes the human figures riding a horse and carrying a sedan chair, plant and octagon patterns as well as independent patterns, horn patterns and border patterns. The bright red background and colorful lines are permeated with ethnic style. At the same time, the animal, plant and human figure images in simple style modernize them artistically.

1　实物来自贵州省毕节市威宁县。

创作手法：计算机软件制图
Creative techniques: computer software drawing

人形纹黎锦筒裙（黎族）
The human-figure-patterned Li brocade tube skirt (the Li ethnic group)

　　黎锦堪称中国纺织史上的"活化石"，历史已经超过3000年，是中国最早的棉纺织品。早在春秋战国时期，史书上就称其为"吉贝布"，其纺织技艺领先中原1000多年。

　　人形纹里最有代表性的是婚礼图，它将黎族婚娶礼仪习俗中的迎亲、送亲及送彩礼和拜堂等活动场面反映在筒裙上，其场面开阔，热烈壮观，内容丰富，具有鲜明的民族特色和浓郁的地域风情。

　　另外，还有舞蹈图、青春幸福图、百人图、丰收欢乐图、人丁兴旺图、放牧图、吉祥平安图等，它寄寓了人们对生育繁衍、人丁兴旺、子孙满堂和追求美好生活的强烈愿望。

The Li brocade can be called a "living fossil" in the history of the Chinese textiles. It has a history of more than 3,000 years and is China's earliest cotton textile. As early as the Spring and Autumn Period and the Warring States Period, Li brocade was called "Jibeibu" in history books, and its textile technology was more than 1,000 years ahead of that in the Central Plains.

The most representative human figure pattern is the wedding design that reflects the Li people's wedding ceremonies, such as welcoming the bride, sending off the bride, and giving gifts and performing the formal wedding ceremony. This scene is warm, spectacular and rich in content, with distinctive ethnic characteristics and strong regional customs.

There are also designs of dancing, happy youth, a hundred people, happy harvest, people's prosperity, grazing, auspiciousness and safety, which embodies the people's strong desire for reproduction, prosperity, offspring and the pursuit of a better life.

创作手法：计算机软件制图
Creative techniques: computer software drawing

彝族纹样创新设计
Innovative design of the Yi patterns

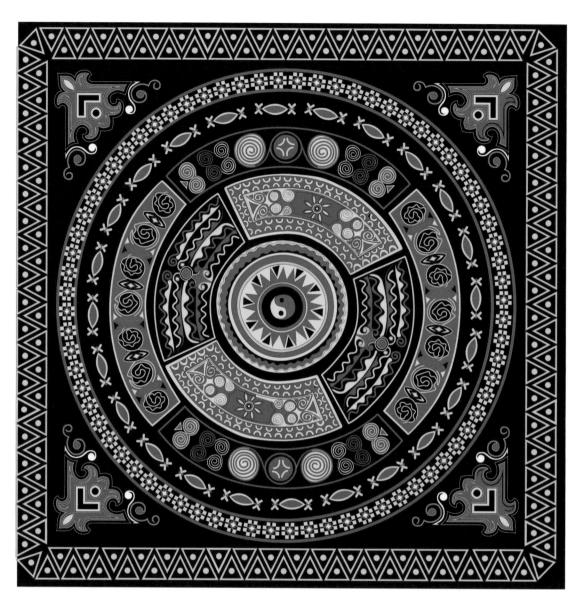

创作手法：计算机软件制图
Creative techniques: computer software drawing

彝族纹样创新设计
Innovative design of the Yi patterns

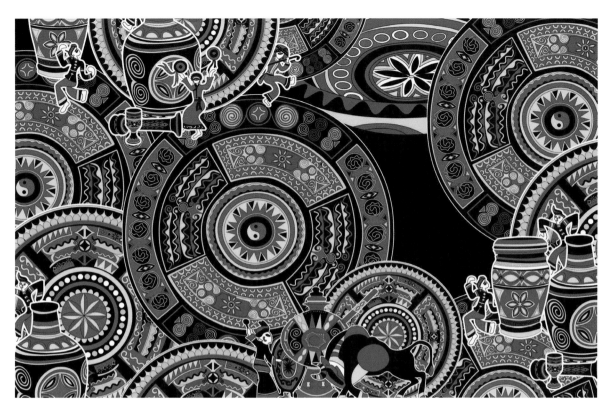

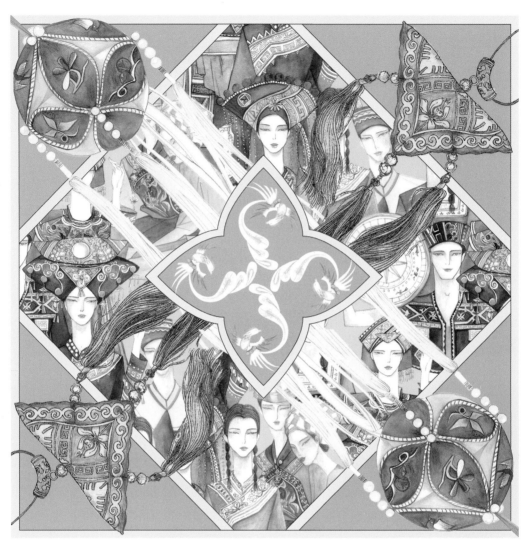

创作手法：计算机软件制图
Creative techniques: computer software drawing

人物纹样创新设计（壮族）
Innovative design of human figure patterns (the Zhuang ethnic group)

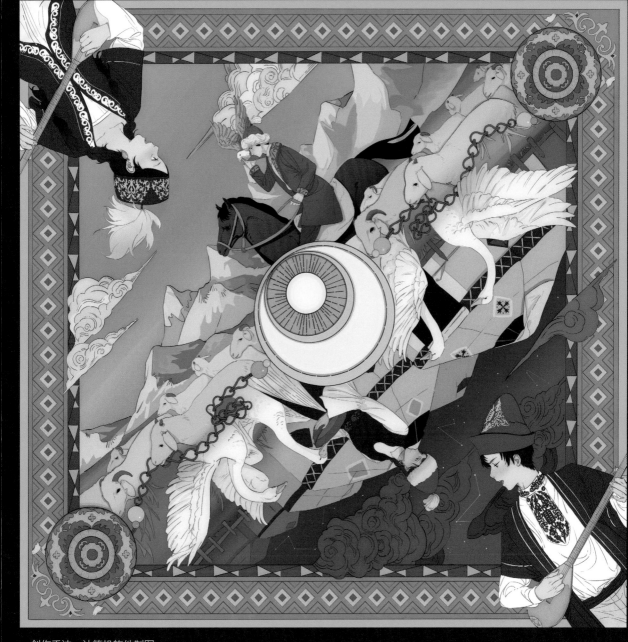

创作手法：计算机软件制图
Creative techniques: computer software drawing

人物纹样创新设计（哈萨克族）
Innovative design of human figure patterns (the Kazakh ethnic group)

CHAPTER 4
CELESTIAL-DERIVED AND
GEOMETRIC PATTERNS
第四章 | 星辰天象与几何化纹样 |

创作手法：计算机软件制图
Creative techniques: computer software drawing

铜鼓太阳纹（壮族）
The sun pattern on the bronze drum (the Zhuang ethnic group)

太阳纹是铜鼓纹的重要组成部分，通常与云雷纹、钱纹、席纹等组合出现，其位于鼓面中心，由光体与光芒组成，光芒放射角的数量和形态是辨别铜鼓纹样类型的标识之一。太阳纹反映了先民对于阳光雨露等自然现象的崇拜。

As a key component of the drum pattern, the sun pattern are commonly decorated in the drum center in combination with cloud thunder, money and mat patterns. It consists of radiation body and rays of light, and the number and shape of the radiant angle can be used to distinguish the bronze drum patterns.

创作手法：计算机软件制图
Creative techniques: computer software drawing

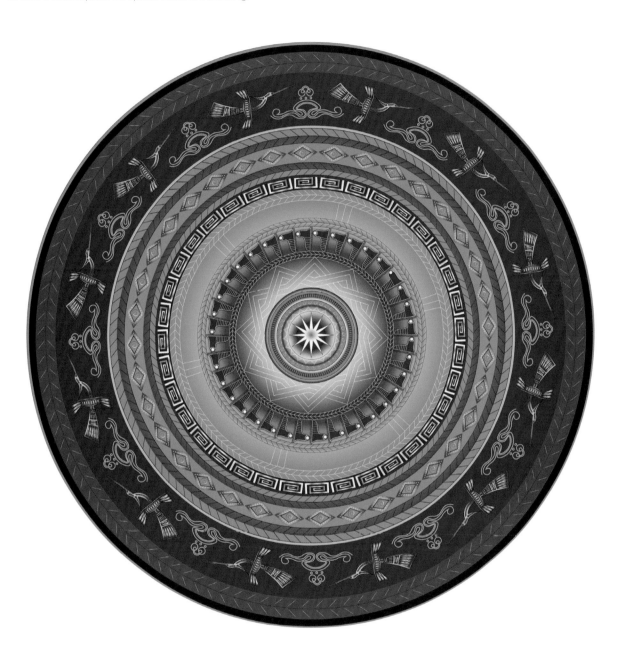

铜鼓太阳纹创新设计（壮族）
Innovative design of the sun pattern on the bronze drum (the Zhuang ethnic group)

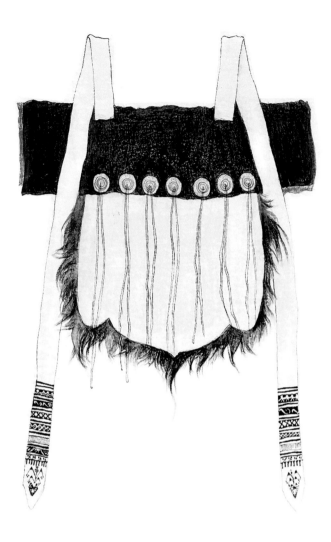

创作手法：彩色铅笔手绘
Creative techniques: color pencil
hand-painting

七星羊皮披肩（纳西族）
A seven-star sheepskin cape (the Naxi ethnic group)

　　纳西族服饰中最富有特色的为"七星羊皮"，防寒保暖又典雅大方。纳西族姑娘将七星图案钉在披肩上，既可起到装饰作用，又可防寒保暖，寓意为披星戴月，勤劳勇敢。

The cold resistant and elegant seven-star sheepskin cape is considered to be one of the most distinctive Naxi costumes. Naxi women nail the seven stars on their capes for ornament,and to resist cold,as well.This kind of cape has carried the connotations of diligence and braveness.

创作手法：计算机软件制图
Creative techniques: computer software drawing

漩涡纹创新设计
Innovative design of the vortex pattern

这个漩涡纹取材自贵州省黔西南州镇宁县的布依族女装袖口上的装饰纹样。其纹样形态可追溯到新石器时代的彩陶纹样上。那时便有着星宿旋转的概念，而七个星宿相连，也许跟先民们对北斗七星的崇拜有关。

This vortex pattern is derived from the decorative patterns on the cuffs of Buyi women's dresses in Zhenning County, Southwest of Guizhou Province. This pattern appeared on the painted pottery in the Neolithic period when ancestors had already formed the concept of the rotating star, and seven coterminous stars are likely to be associated with ancestors' worship of the Big Dipper.

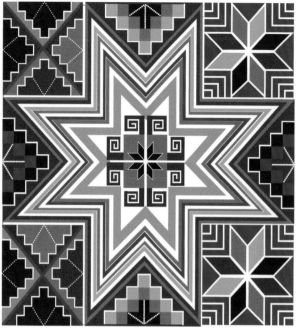

创作手法：计算机软件制图
Creative techniques: computer software drawing

盘王印
Pan Wangyin

八角星纹样
The octagon pattern

　　八角星纹，呈米字形，八角、上下左右对称，在西南地区少数民族纹样里十分常见。这个纹样可追溯至古老的八角星符号，它与考古天文学有着密切的联系。在不同民族的装饰纹样中，八角花纹的表现形式千变万化，各具特色，是民族纹样中最具代表性的符号之一。

The octagon pattern in the shape of a star has eight corners and is symmetrical both horizontally and vertically, which is commonly seen in the patterns of ethnic minorities in the Southwest. The source of this pattern can be traced back to the ancient eight-pointed star symbol, and it is closely related to archaeoastronomy. Among the decorative patterns of different ethnic groups, the octagon pattern has various forms of expression, each with its own characteristics, and it is one of the most representative symbols in ethnic patterns.

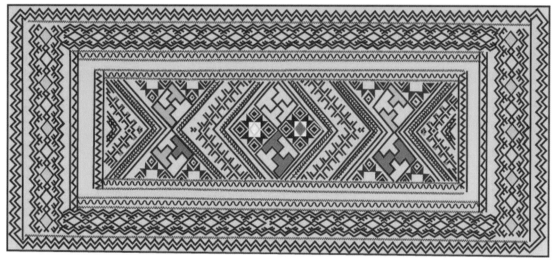

创作手法：计算机软件制图
Creative techniques: computer software drawing

几何纹样 （苗族）
The geometric patterns (the Miao ethnic group)

　　几何纹样是苗族刺绣最常见的图案之一。其原型源于自然界天象及动植物的形态，主要有星辰纹、云纹、太阳纹、月亮纹、圆点纹、江河纹、雷纹、回形纹、漩涡纹、万字纹、山川纹、鱼纹、蝴蝶纹、龙纹、十字纹、八角花纹等40余种。表达了苗族"万物有灵"的思想观念，体现了苗族人民对于生活与自然的理解和热爱。

Geometric patterns are one of the most common patterns in Miao embroidery. As their prototypes are derived from the celestial phenomena and the forms of animals and plants in nature, the geometric patterns are a collection of nearly 40 patterns of the star, cloud, sun, moon, polka dot, river, thunder, fret, water swirl, swastika, mountain, fish, butterfly, dragon and cross. They not only express the Miao people's concept of thinking that "everything has a soul", but also reflect their understanding of and love for life and nature.

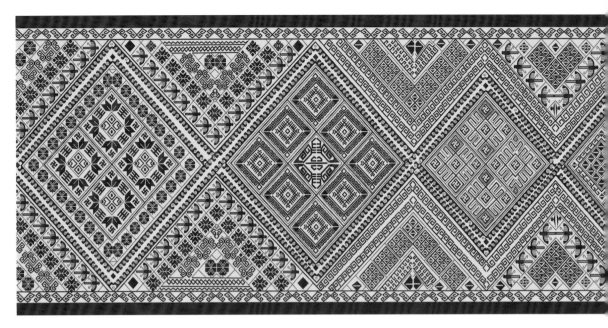

织锦背扇心（苗族）¹
Brocade Beishan patterns（the Miao ethnic group）

1　实物来自江西省赣州市寻乌县丹溪乡。

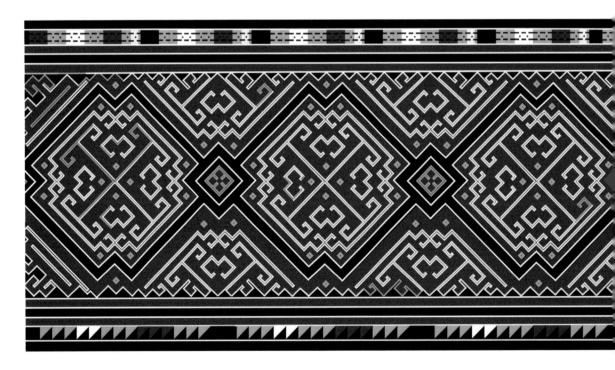

织锦绣片¹
The brocade piece

1　实物来自贵州省黔东南州黄平县重安镇。

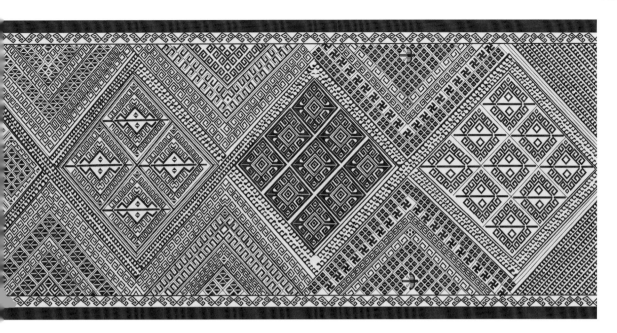

创作手法：计算机软件制图
Creative techniques: computer software drawing

鸟纹、几何纹、万字纹等
bird patterns, geometric patterns, swastika, etc.

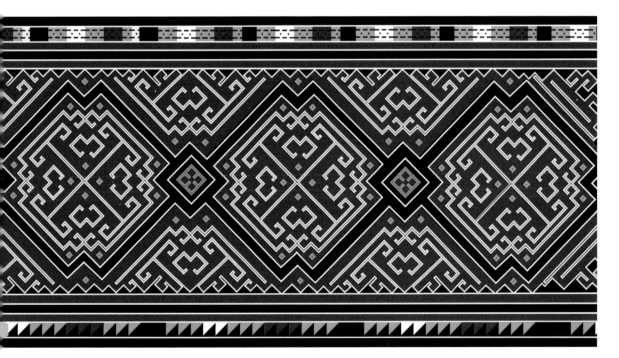

创作手法：计算机软件制图
Creative techniques: computer software drawing

挑花几何纹样
cross-stitch geometric patterns

创作手法：计算机软件制图
Creative techniques: computer software drawing

数纱绣绣片（苗族）[1]

Embroidery piece with the counted cross stitch (the Miao ethnic group)

苗族数纱绣多为从绣地反面数纱刺绣，取正面图案。数纱绣的绣地通常是平纹棉布，贵州黄平地区的绣娘将质地细腻的丝质面料附在平纹棉布的正面，在两层面料上同时进行刺绣，以反面的平纹面料数纱刺绣，正面的丝绸面料上则呈现出均匀细致的数纱绣图案。此款绣品主纹样为刺梨花几何纹，以金黄色丝线与蓝灰底色相搭配，朴素典雅，体现了几何对称图形的工整美感。

The Miao people's counted cross stitch starts with the reverse side of the ground fabric and forms patterns on the front side. The ground fabric for counted cross stitch is usually plain-weave cotton fabric. The embroiderers from Huangping area of Guizhou attach fine-textured silk fabric to the front side of the plain-weave cotton fabric, and embroider on two layers of fabric at the same time. As the counted cross stitch is applied on the reverse side of the plain-weave cotton fabric, a uniform and detailed counted cross stitch pattern is formed on the silk fabric on the front side. The main pattern of this embroidery is the geometric pattern of prickly pear flowers. The golden silk thread is matched with the blue-gray background, which is simple and elegant, and reflects the visually neat beauty of symmetrical geometric patterns.

1 实物来自贵州省黔东南州黄平县。

创作手法：计算机软件制图
Creative techniques:
computer software drawing

织锦纹样创作（苗族）
Design of brocade patterns (the Miao ethnic group)

创作手法：计算机软件制图
Creative techniques:
computer software drawing

数纱绣纹样创作（苗族）
Design of counted cross stitch patterns (the Miao ethnic group)

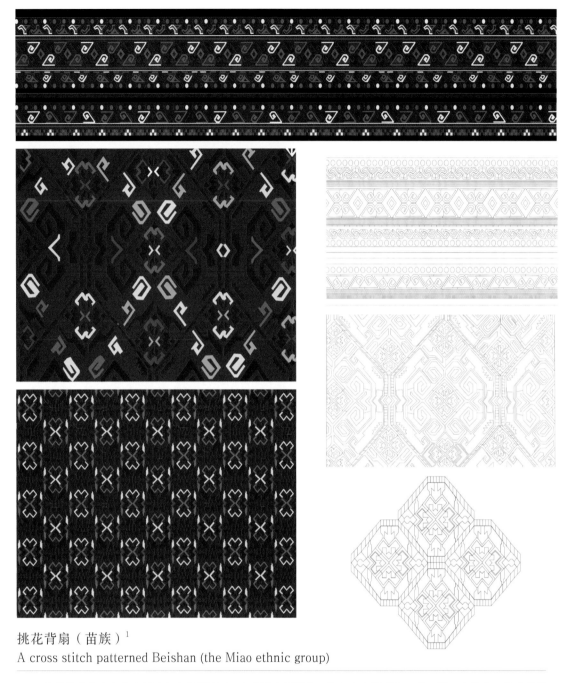

挑花背扇（苗族）[1]

A cross stitch patterned Beishan (the Miao ethnic group)

　　此款挑花背扇来自贵州黔东南黄平地区，主纹样为刺梨花，紫红底色搭配红、蓝、绿、白等色，整个背带绣工精美，色彩搭配明快和谐。刺梨花纹样在苗族的衣袖、背扇挑花绣品中极为常见，对称的几何造型基本上以四方连续纹样形式出现，工整细腻，朴实含蓄。

This cross stitch patterned beishan is from the Huangping area in southeast Guizhou. The main pattern is the prickly pear flower. The red-violet background is matched with red, blue, green and white colors. The entire strap is beautifully embroidered and the colors are bright and harmonious. The prickly pear flower pattern is commonly seen on the Miao people's sleeve and Beishan embroidery. Symmetrical geometric patterns basically appear in the form of continuous patterns in four directions which are neatly, delicate and subtly simple.

1　实物来自贵州省黔东南州黄平县。

创作手法：计算机软件制图
Creative techniques: computer software drawing

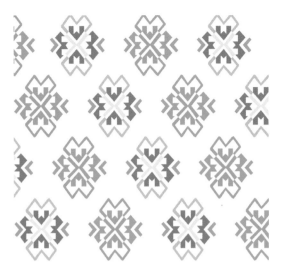

创作手法：计算机软件制图
Creative techniques: computer software drawing

挑花背扇纹样提取与创作
Extraction and design of the cross stitch pattern on Beishan

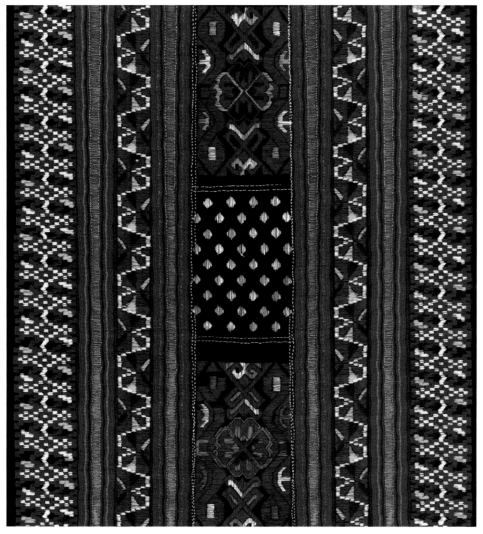

创作手法：计算机软件制图
Creative techniques: computer software drawing

桌旗绣片（苗族）[1]
A piece of embroidered table runner (the Miao ethnic group)

此款图案为一款现代桌旗上的局部纹样，其制作方法是将传统服饰上的老绣片裁切下来后，与现代的布料拼合而成。其主纹样为刺梨花、几何纹，黑红主色点缀白、绿、黄等色。用老绣片与现代工艺结合创作新工艺品是目前民族地区较为普遍的旅游纪念礼品制作形式。

This design is part of the patterns on an embroidered table runner. To make such design, an old embroidery piece is cut from a traditional clothes and is then combined with modern fabrics. The main patterns are the prickly pear flower pattern and geometric pattern, and the main colors of black and red are dotted with white, green and yellow colors. The new crafts that combine old embroidery pieces and modern craftsmanship are common travel souvenirs in ethnic areas.

1 实物来自贵州省黔东南州黄平县。

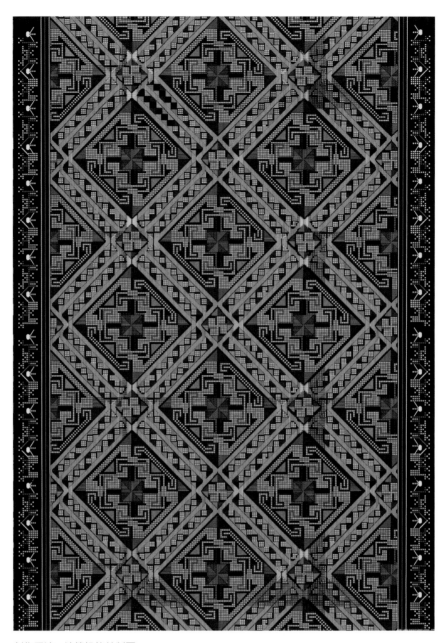

创作手法：计算机软件制图
Creative techniques: computer software drawing

十字纹样数纱绣绣片（苗族）
Cross patterned embroidery piece with the counted cross stitch
(the Miao ethnic group)

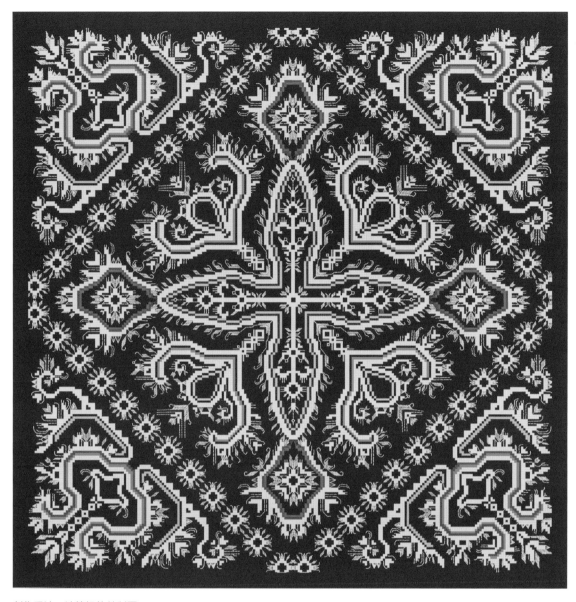

创作手法：计算机软件制图
Creative techniques: computer software drawing

数纱绣绣片（苗族）[1]
Counted cross stitch patterned embroidery piece(the Miao ethnic group)

1　实物来自贵州省贵阳市花溪区。

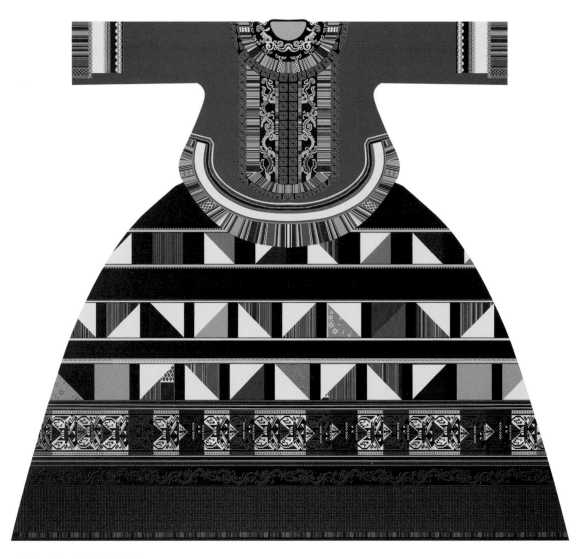

创作手法：计算机软件制图
Creative techniques: computer software drawing

女装（彝族）[1]
A women's costume (the Yi ethnic group)

1 实物来自云南省文山州麻栗坡县。

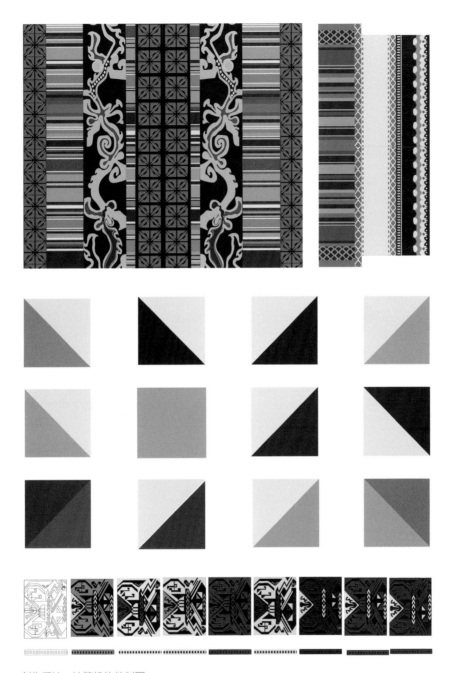

创作手法：计算机软件制图
Creative techniques: computer software drawing

女装纹样提取（彝族）
Extraction of the women's costume pattern (the Yi ethnic group)

创作手法：计算机软件制图
Creative techniques: computer software drawing

万字流水纹创新设计（土家族）
Innovative design of the infinite swastika pattern (the Tujia ethnic group)

万字是吉祥符号中较为常见的一种。此幅万字流水纹颜色肃静、图案单纯，万字隐藏在双勾的横向纹样中，既似抽象几何图案，又为明显的万字牵带，设计巧妙。万字纹在传统图案中表示万寿万福，民间图案也经常使用它来传达这一美好愿望。

The "Swastika", as a character, is one of the common auspicious symbols. The color of this infinite swastika pattern is calm and the design is simple. The character swastika is hidden in the double-sided horizontal lines. The ingenious design which looks like an abstract geometric pattern and an obvious swastika tie at the same time. The swastika pattern in traditional patterns means longevity and happiness, and the folk designs often use it to convey this good wish.

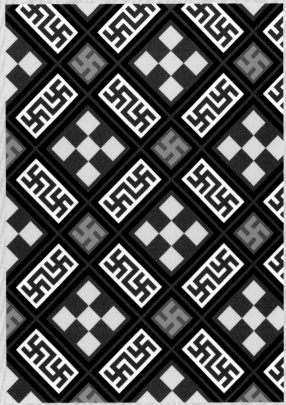

创作手法：计算机软件制图
Creative techniques: computer
software drawing

玉章盖纹创新设计（土家族）
Innovative design of the Yuzhanggai pattern（the Tujia ethnic group）

玉章盖是土家族被面的意思，多用二方连续或四方连续的几何纹样表现韵律感和节奏感，没有曲线，而多为抽象的三角形、菱形、四边形。

Yuzhanggai means quilt cover in Tujia language. It adopts continuous geometric patterns in two directions or four directions to express rhythm and beats in an abstract and exaggerated manner. The geometric shapes include triangles, rhombuses and quadrilaterals without curves.

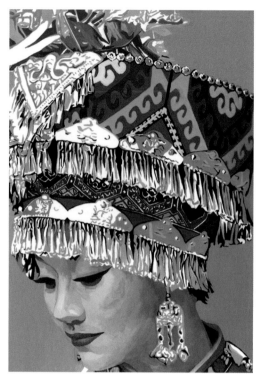

创作手法：水粉手绘
Creative techniques: poster color hand-painting

四十八勾花纹（土家族）
The 48-crochet pattern（the Tujia ethnic group）

　　四十八勾由八勾发展而来，经历双八勾、二十四勾到四十八勾而成的抽象纹样。它以四个菱形点组成的方块为中心，组成三层四十八勾六边形纹样，将天、地、人、神、物、社会联系在一起，表达事事顺心、生命不止、繁衍不息的寓意。

The 48-crochet is an abstract pattern developed from the 8-crochet and later experienced the double 8-crochet and 24-crochet. Its center is a square composed of four rhombus spots, and it consists of three layers of 48-crochet hexagon pattern which connects heaven, earth, people, gods, things and society all together. With this pattern, the Tujia people pray that everything will go well, the people will live forever, and their offspring will prosper.

创作手法：计算机软件制图
Creative techniques: computer software drawing

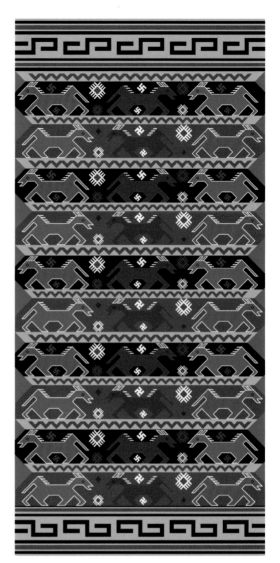

创作手法：计算机软件制图
Creative techniques: computer software drawing

马毕花纹（土家族）
The Mabihua pattern（the Tujia ethnic group）

　　马毕花即马形纹样，由直线和斜线勾画马嘴、身体、四肢，呈现出几何形。不受自然形态约束，概括、抽象展现马的侧面形态，加以冷暖色调交错，将色彩对比的美感发挥到极致。

Mabihua is a horse-shaped geometric pattern that outlines a horse's muzzle, body and limbs using straight and diagonal lines. Unconstrained by the natural form, the pattern summarizes and abstracts the horse's lateral form, with interlaced warm and cold tones, pushing the color contrast to the extreme.

创作手法：计算机软件制图
Creative techniques: computer software drawing

创作手法：水粉手绘
Creative techniques: poster color hand-painting

台台虎纹（土家族）
The Taitaihu pattern（the Tujia ethnic group）

　　土家族祖先以白虎为图腾，因此，虎的形象多见于各种织锦纹样之中。台台虎多用于摇篮围盖上。主体纹样酷似"虎头"，眉眼清晰可辨，中间矩形与倒三角形形成了老虎鼻子，整体图形极其概括抽象，具有现代感。

The Tujia people's ancestors took the white tiger as their totem. Therefore, tiger images are common in various brocade patterns. Taitaihu is frequently seen on cradle covers. The continuous pattern in two directions is called "Tai", and the main pattern resembles the "tiger's head". The eyebrows are clearly distinguishable, and the rectangle and inverted triangle in the center form the tiger's nose.

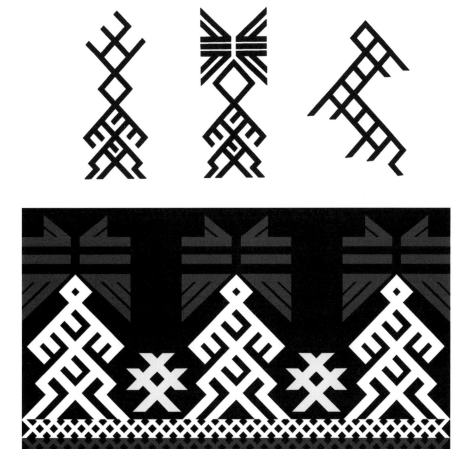

创作手法：计算机软件制图
Creative techniques: computer software drawing

几何人形纹（瑶族）
Geometric human figure patterns (the Yao ethnic group)

　　瑶族图案种类繁多，且形式变化多样，具有代表性的图案有人形纹、植物纹、几何纹等，广泛地应用到衣领、腰带、头饰等方面。其中几何人形纹高度抽象概括，寓意人口繁茂、社会昌盛。

The Yao patterns are of many kinds and their forms vary. The representative patterns such as human figure patterns, plant patterns and geometric patterns are widely used on collars, belts, headwears, etc. Among them, the human figure patterns is designed in a highly abstract and summative manner, symbolizing robust population growth and nation's prosperity.

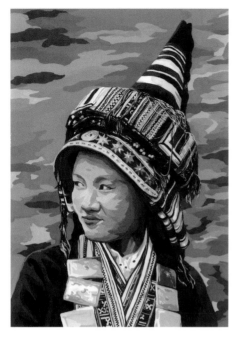

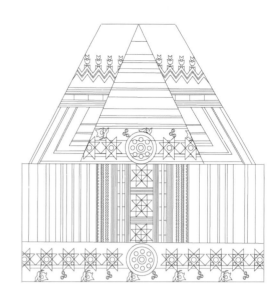

创作手法：水粉手绘
Creative techniques: poster color hand-painting

尖头瑶 [1] 帽饰图案（瑶族）
Jiantou Yao hat design (the Yao ethnic group)

　　三角塔形帽子是尖头瑶族女子比较显著的标志，帽子多由十余条方布条缝制而成。瑶族服饰多运用几何纹样，一般采用四面均齐或左右对称，力求整体效果的统一，点、线、面组成的图案纹样配合得当，主次分明，疏密有致，富有节奏感和韵律感。

The triangular tower hat is a more prominent sign of the Jiantou Yao women. The hat is sewed with more than ten layers of square strips. The Yao costumes often use geometric patterns which are generally unified or symmetrical on all sides to strive for the unity of the overall effect. Therefore, the patterns composed of points, lines and planes are properly matched, and aesthotically pleasing.

1 尖头瑶，是瑶族的一个支系，因女子头饰是尖头状，被称为"尖头瑶"。（资料来源：广东瑶族博物馆）

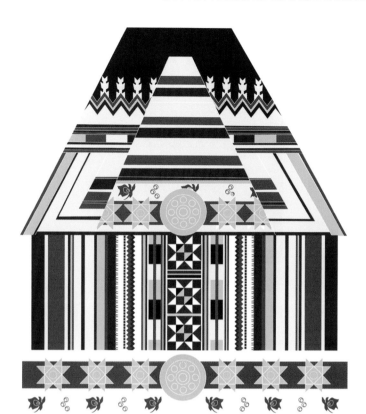

创作手法：计算机软件制图
Creative techniques: computer software drawing

创作手法：计算机软件制图
Creative techniques: computer software drawing

过山瑶 [1] 帽饰图案（瑶族）
Guoshan Yao hat design (the Yao ethnic group)

1 过山瑶，中国四大瑶族支系之一，以广东省乳源瑶族自治县为中心地区分布。

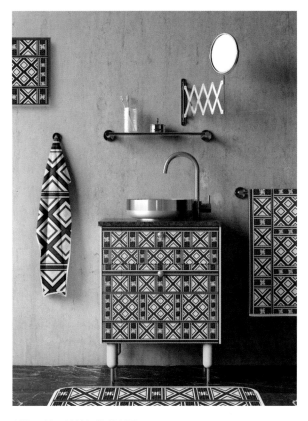

创作手法：计算机软件制图
Creative techniques: computer software drawing

"十"字纹（瑶族）
The "cross" pattern (the Yao ethnic group)

创作手法：计算机软件制图
Creative techniques:
computer software drawing

几何植物纹（瑶族）
The geometric and plant pattern(the Yao ethnic group)

　　瑶族服饰中的植物纹样多用简洁而抽象的线条构成，取材自然，多为生活中常见的花草树木等植物。此纹样为二方连续的树纹，每组树纹大小形式各有不同，配色风格强调冷暖对比。树纹多绣在显著部位，如图的顶部。因为瑶族先民是以采集和狩猎为生的，所以自然而然地就形成了对树的崇拜。

The plant patterns composed of simple and abstract lines in Yao costumes mostly take elements from nature , such as common flowers and trees in daily life. The patterns are two-sided continual tree patterns. Each set of tree patterns with warm and cold color contrast vary in size and form. Most of the tree patterns are embroidered on the prominent part, such as the top of this picture. Since the Yao people's ancestors took gathering and hunting as their main source of income, they naturally formed a worship of trees.

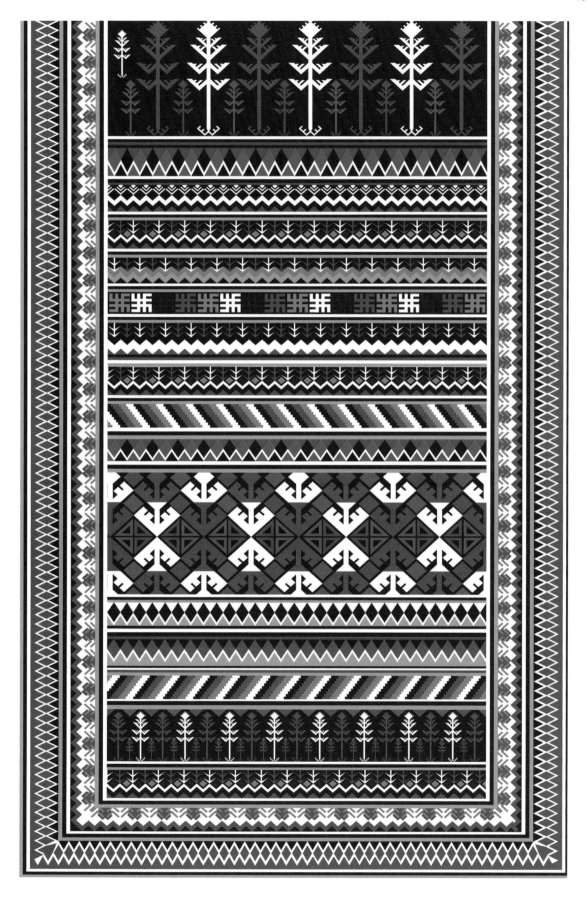

壮锦中的几何纹样
Geometric patterns on the Zhuang brocade

壮锦，与云锦、蜀锦、宋锦并称中国四大名锦，据传起源于宋代，是中华民族的文化瑰宝之一。壮锦在壮文中的含义为天纹之页，这种利用棉线或丝线编织而成的精美工艺品，自然生动，严谨有序，色彩艳丽，充满了热情奔放的民族性格，既体现了壮族人民对自然的崇敬，也体现了他们对美好生活的追求与向往。

Zhuang brocade, together with Yun brocade, Shu brocade and Song brocade, is recognized as China's four most famous schools of embroidery. Zhuang brocade is said to be originated in the Song Dynasty and is one of China's cultural treasures. Zhuang brocade in Zhuang language means the page of sky pattern. This exquisite handicraft woven with cotton or silk threads is naturally vivid, orderly rigorous, colorful, and full of enthusiasm and unrestrained ethnic characters. It reflects not only the Zhuang people's respect towards nature, but also their pursuit of a better life.

几何纹样是以点、线、面组成的方格、三角、八角、菱形、圆形、多边形等有规则的图纹，包括以这些图纹为基本单位，经往复、重叠、交错处理后形成的各种形体。一般以抽象型为主，也有和自然物象配合成纹者，是传统织绣中最常用的纹饰之一。在图案组织上，几何形在壮锦图案中占重要位置，显示了图腾观念或某种秩序感。壮锦中常见的几何纹样有：勾连云纹、雷纹、方格纹、水波纹、编织纹、同心圆纹、羽状纹、弦纹等。

Geometric patterns are regular patterns such as squares, triangles, octagons, rhombuses, circles and polygons composed of points, lines and planes, including the various shapes formed by these patterns as the basic units by means of reciprocating, overlapping and interlacing. In general, abstract types are the main ones, and there are also patterns matched with natural objects, which are one of the most commonly used patterns in traditional weaving and embroidery. In terms of pattern organization, geometric shapes play an important role in Zhuang brocade designs, showing the concept of totem or a sense of order. The common geometric patterns on Zhuang brocade mainly include the interlocked cloud, thunder, square grid, water ripple, woven shape, concentric circle, feather and string.

菱形纹是壮锦图案几何纹样中出现频率比较高的一种，它是古代先民从编席实践中受到启发后所创的织物纹样，为传统矩形纹中的一种，通常呈等长四边形，上下左右四角相对。除规则矩形菱形纹外，还出现许多变体菱形纹，如菱形纹与菱形纹叠压相交，名谓"方胜"，还有在菱形界格内填入其他纹样的图案样式。

The rhombus pattern is one of the most frequently used geometric patterns on Zhuang brocade. It is a fabric pattern created by the ancestors inspired by the practice of mat weaving. As one of the traditional rectangular patterns, the rhombus pattern is usually in a quadrilateral shape of equal length, and the four corners are opposite to each other. In addition to the regular rectangular and rhombus patterns, there are also many variant rhombus patterns, such as the overlapped and intersected rhombus patterns called "Fang-sheng", and the patterns that are formed by filling other patterns in the rhombus borders.

创作手法：计算机软件制图
Creative techniques: computer software drawing

创作手法：计算机软件制图
Creative techniques: computer software drawing

壮族几何纹样创作
Design of the Zhuang geometric patterns

创作手法：计算机软件制图
Creative techniques: computer software drawing

壮族几何纹样创作
Design of the Zhuang geometric patterns

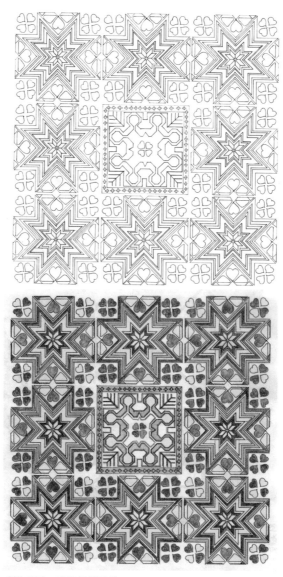

创作手法：彩色铅笔手绘
Creative techniques: color pencil drawing

八角星纹样（傈僳族）
The octagon pattern (the Lisu ethnic group)

傈僳族妇女常将月亮和星星绣在其民族服装的袖口、裤脚花边上，取 "披星戴月" 之意，寓意着傈僳族人民勤劳、吃苦耐劳的美德。

Lisu women often embroider the moon and star patterns on the cuffs and leg openings of their ethnic costumes, which means working late, to imply the virtues of the Lisu people's diligence.

创作手法：马克笔手绘
Creative techniques: color marker pen drawing

创作手法：铅笔手绘 计算机软件制图
Creative techniques: pencil drawing
computer software drawing

傈僳族几何图案提取与创作
Extraction and design of the Lisu geometric patterns

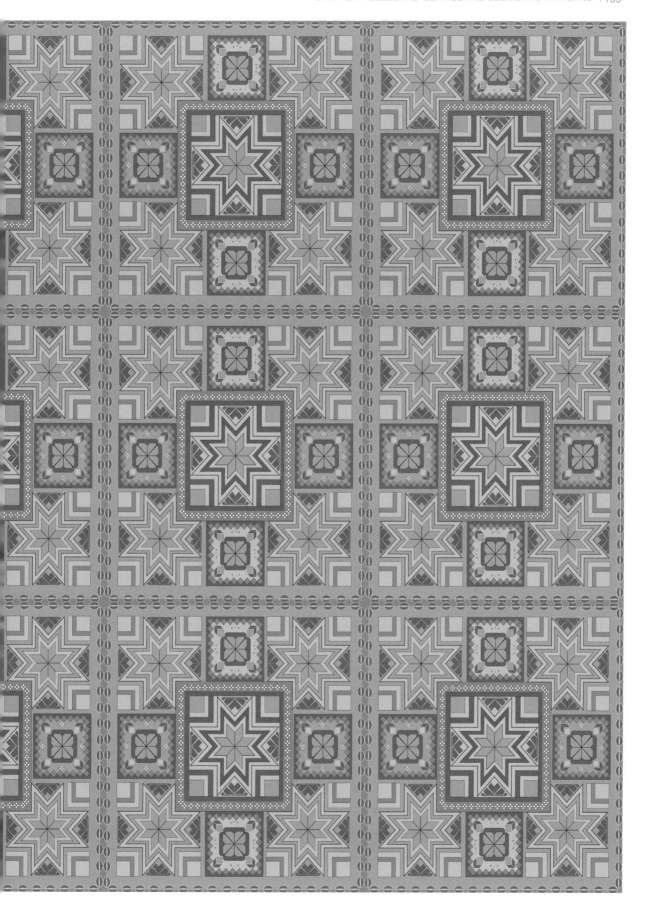

创作手法：马克笔手绘 计算机软件制图
Creative techniques: color marker pen drawing
computer software drawing

僳僳族几何图案提取与创作
Extraction and design of the Lisu geometric patterns

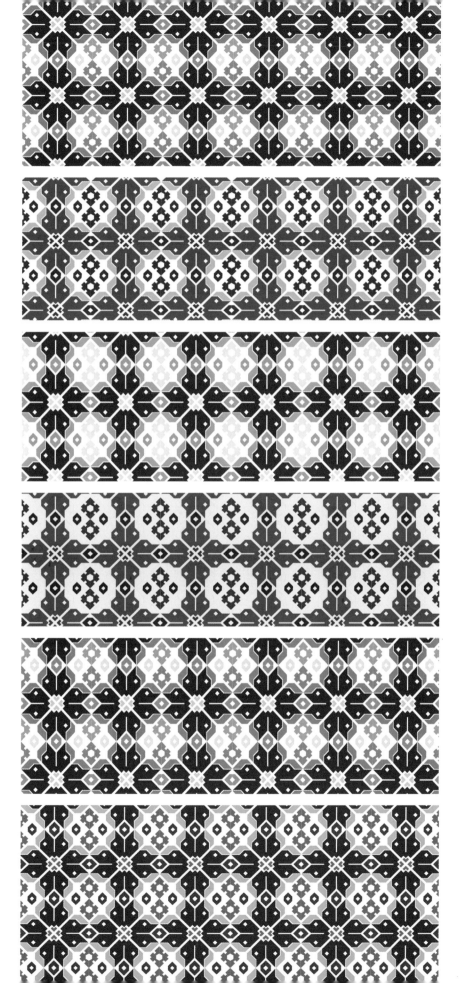

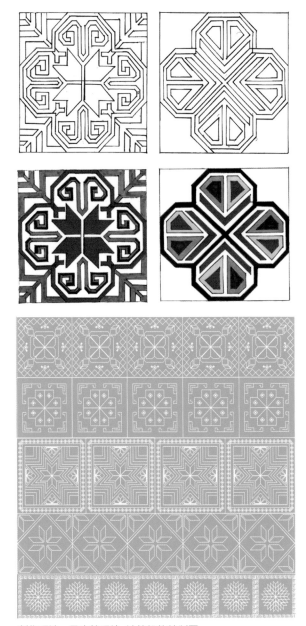

创作手法：马克笔手绘 计算机软件制图
Creative techniques: color marker pen drawing
computer software drawing

傈僳族几何图案提取与创作
Extraction and design of the Lisu geometric patterns

创作手法：马克笔手绘 计算机软件制图
Creative techniques: color marker pen drawing
computer software drawing

傈僳族几何图案提取与创作
Extraction and design of the Lisu geometric patterns

CHAPTER5
PATTERN APPLICATION
ON COMPREHENSIVE MATERIALS
第五章 | 综合材料之纹样应用 |

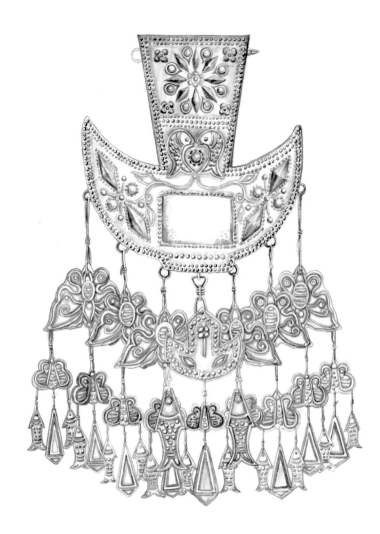

创作手法：铅笔手绘
Creative techniques: pencil
drawing

笆篓形银吊饰（侗族）

The basket-shaped sliver pendant (the Dong ethnic group)

笆篓，是一种用竹篾或荆条编织的盛器，纹路简洁、明晰，笆篓形银吊饰则采用了笆篓的几何造型让笆篓的形象从后背转到腰间，成为从江苗侗地区青年男子典型的腰间配饰。

笆篓形银吊饰韵味十足，集笆篓形象、功能、寓意于一体。中空，似《道德经》"有之以为利，无之以为用"之意，更显银饰纤巧、玲珑。配以象征富贵的双鱼纹，象征高洁的梅花，连珠及乳钉纹，下坠蝴蝶、鱼、响铃吊穗等，既形象生动，又丰富饱满。

The basket-shaped silver pendant is full of charm, integrating the basket's image, function, and meaning. Its hollow shape resembles the meaning of the Tao De Jing saying that "something is profitable, but seeing nothing for use". It shows the delicacy and exquisiteness of the silver decoration, which was engraved with some vivid and rich images including the double fish pattern symbolizing wealth, and the plum blossom symbolizing nobleness, the pearl, the nail pattern, the falling butterfly, the fish, the bell, and the tassel.

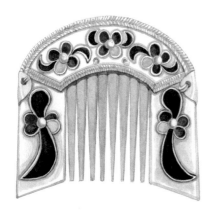

创作手法：水粉手绘
Creative technique: poster color hand painting

錾花珐琅包银木梳（侗族）
The engraved silver covered wooden comb with embedded enamel (the Dong ethnic group)

　　錾花珐琅包银木梳，以银作底材，大花大叶，花朵饱满，花瓣短而肥腴，叶伸展有力，线条简洁流畅，彰显华贵。侗族女人一生离不开木梳，亦梳亦戴，生活与装饰合而为一。

Taking silver as the base material, the wooden comb is decorated with big flowers and big leaves. The flowers in full bloom have short and fleshy petals, and are accompanied with strong stretching leaves. The simple and smooth lines highlight luxury. The Dong women cannot do without wooden combs all their lives. They either use them or wear them, making them an important part in their life.

创作手法：水粉手绘
Creative techniques: poster color hand painting

多棱角螺蛳形背吊（侗族）
The freshwater snail-shaped back sling (the Dong ethnic group)

　　银质多棱角螺蛳形背吊呈双钩形，钩尖盘成螺蛳状，正中立多棱角形体。侗族妇女穿围腰时将背吊装饰在背后，起控制、平衡胸前围腰的作用。

The freshwater snail-shaped silver back sling is in the shape of a double hook, and the hook tip is in the shape of a snail, with a standing polygonal body in the middle. When the Dong women wear waistbands , they put the decorations on the back to control and balance the waistbands.

创作手法：水粉手绘
Creative techniques: poster color hand painting

银耳圈（侗族）
Silver earrings (the Dong ethnic group)

创作手法：铅笔手绘
Creative techniques: pencil drawing

银项圈（苗族）
The silver collar necklace (the Miao ethnic group)

苗族银饰纹样多取自天地万物，有蝴蝶纹、鱼纹、鸟纹、蜘蛛纹、蝉纹、花草纹、树木纹等，表达了苗族人民对自然的热爱。

此项圈为串戒指项圈，以篓花银片为内圈，用16枚戒指串成，为避免戒指重叠，以银丝将戒指等距固定，戒指表面上的图案由蝴蝶纹、花鸟纹等组成，其造型华丽，风格独特。

The patterns of Miao silver jewelry are mostly taken from nature, and the patterns of the butterfly, fish, goose, spider, cicada, flower and tree express the Miao people's passion for nature.

This collar necklace has sixteen rings threaded on it with flower engraved silver flakes as the inner ring. In order to avoid overlapping, the rings are fixed equidistantly with silver wires. The patterns on the rings include butterflies, flowers, birds, fish, and insects. The necklace is gorgeous and of unique style.

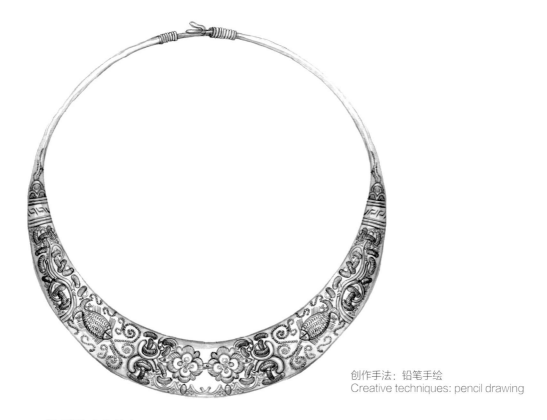

创作手法：铅笔手绘
Creative techniques: pencil drawing

银项圈（苗族）
The silver collar necklace (the Miao ethnic group)

创作手法：铅笔手绘
Creative techniques: pencil drawing

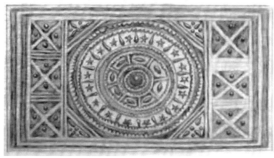

银饰（瑶族）
The silver jewelry (the Yao ethnic group)

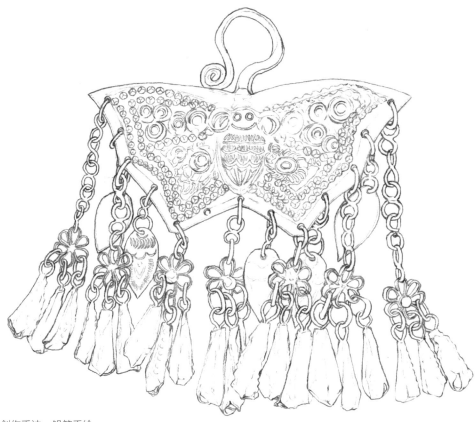

创作手法：铅笔手绘
Creative techniques: pencil drawing

银耳环（苗族）
Silver earrings (the Miao ethnic group)

苗族银耳环取材多样，花、鸟、蝶、龙，蜻蜓等均可作为素材，写实与寓意结合，造型真实，构思精巧，创新大胆。

此银耳环主体为蝴蝶形状，苗族纹样中的蝴蝶意象多取自其神话传说中的"蝴蝶妈妈"的神话人物形象。

The elements of the Miao silver earrings range from flowers, birds, butterflies, dragons to dragonflies. combining realism with meaning. The earrings are of realistic shapes, exquisite designs and bold innovation.

These silver earrings resemble a butterfly shape which is inextricably linked with the myths and legends "butterfly mother" of the Miao people.

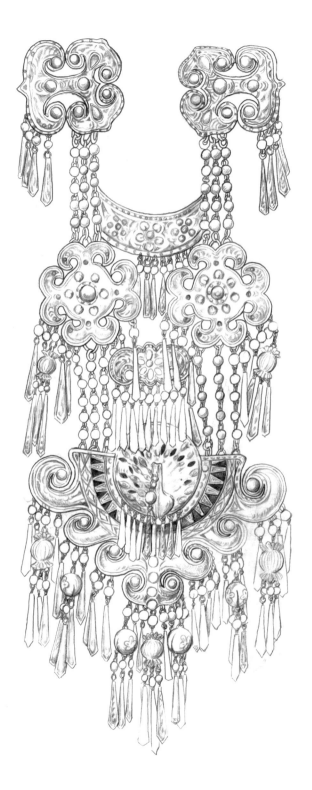

创作手法：铅笔手绘
Creative techniques: pencil drawing

银饰（彝族）
The silver jewelry (the Yi ethnic group)

　　彝族银饰图案亦取材于大自然，凡有之物皆可作饰。其中代表性的有鸡冠纹、蕨草纹、羊角纹、牛角纹、兽牙纹、绳花、火镰纹、日月纹、鸟纹、龙纹、孔雀纹、神马纹，以及各种点、线类的几何纹。

The Yi people's silver patterns are also based on nature, and everything that exists can be decorated. The representative ones are the cockscomb pattern, fern pattern, sheep horns pattern, oxhorn pattern, animal tooth pattern, aglet , fire sickle pattern, sun and moon pattern, bird pattern, dragon pattern, peacock pattern, mythical horse pattern, and geometric pattern of various dots and lines.

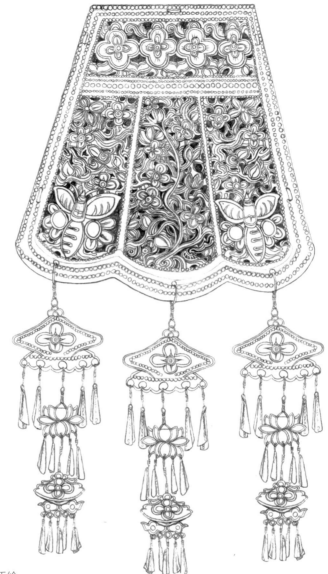

创作手法：铅笔手绘
Creative techniques:pencil drawing

银披肩（壮族）
The silver shawl (the Zhuang ethnic group)

此银披肩由同样图案的八片组成，上图为其中一片，内有蝴蝶纹、花草植物纹等。银饰周边饰有大量乳钉纹，以衬托立体形象，突显厚重感，令构图更为丰满。

This silver shawl is composed of eight pieces of the same pattern, with butterfly and plant patterns inside. It is decorated with a large number of spikes on the edge to set off the three-dimensional image, highlighting the weight and enriching the composition.

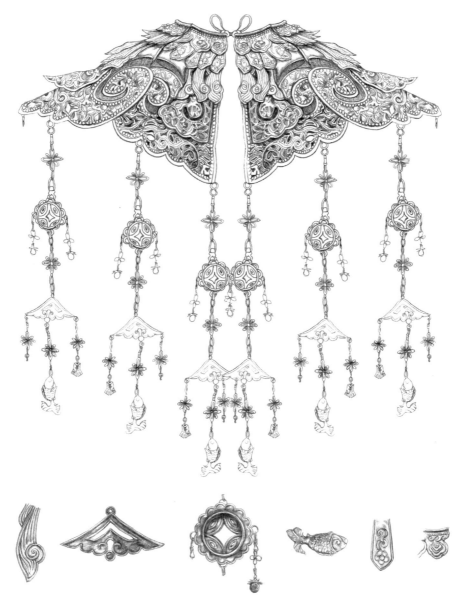

创作手法：铅笔手绘
Creative techniques: pencil drawing

绣球纹、云纹银披肩（壮族）
A silver shawl with the embroidered ball pattern and cloud pattern (the Zhuang ethnic group)

　　此银披肩收藏于云南省博物馆，由图案相同的 4 片组成，前胸、背部各两片，由植物花卉、云纹、鱼纹、绣球、连珠等纹样构成。

This silver shawl is now kept in the Yunnan Provincial Museum. It is composed of 4 pieces of the same pattern, two pieces for the chest and two for the back, decorated with plant patterns, cloud patterns, fish patterns, embroidered ball patterns and astragal patterns.

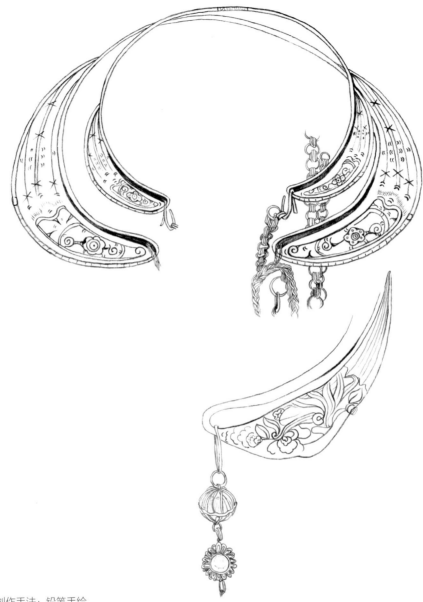

创作手法：铅笔手绘
Creative techniques: pencil drawing

双鱼对吻银项圈（壮族）
The kissing-fish silver collar necklace (the Zhuang ethnic group)

　　双鱼对吻银项圈两边形状如鱼，佩戴之时如双鱼对吻，内饰花草图纹，线条滑润优美，细致生动。

The two sides of the necklace are shaped like fish, and when worn, it looks like a pair of fish kissing each other. The inside is decorated with plant patterns, and the lines are delicate and vivid.

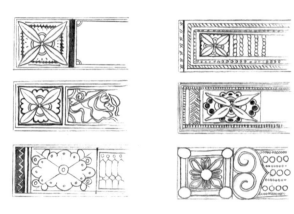

银手镯（壮族）
The silver bangle (the Zhuang ethnic group)

　　银手镯是壮族青年男女的定情信物，也是婚嫁必备物品。多为一指宽薄片，或似藤，曼叶镶珠。

A silver bangle is a token of love for young men and women of the Zhuang ethnic group, as well as a necessary item for marriage. The bangle is mostly a finger-wide thin slice, or in the shape of a vine, with scattered leaves and beads.

　　手镯上的纹样包含花草纹、几何纹、连珠纹等。

The patterns include the flower and the grass, geometric shape and astragal.

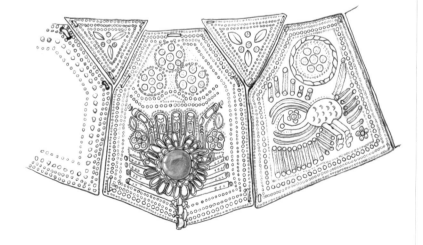

创作手法：铅笔手绘
Creative techniques: pencil drawing

银头饰（壮族）
The silver headdress (the Zhuang ethnic group)

　　此银头饰共八片组成，由凤凰纹和植物纹构成，主要采用镶嵌的工艺制作手法。

This silver headdress consists of 8 pieces with phoenix patterns and plant patterns, and is mainly made with inlay techniques.

创作手法：铅笔、彩色铅笔手绘
Creative techniques: pencil,color pencil drawing

绣球（壮族）
Embroidered balls (the Zhuang ethnic group)

绣球是由彩绣做成的民间吉祥物，大多为 12 瓣，多以红、黄、绿三色做面料底色，每瓣皆用金丝或彩线绣上各式吉祥物，图案样式主要有龙、凤凰、鸳鸯、喜鹊、仙鹤、蝴蝶、梅兰竹菊、松树、牡丹、水仙、荷花，寓意"万寿如意""岁岁平安""百年好合"等。

Embroidered balls are folk mascots made of colorful embroidery. Most embroidered balls have 12 petals mainly using red, yellow and green background fabric. Each petal is embroidered with various mascots with gold or colored threads. The patterns mainly include the dragon, phoenix, mandarin duck, magpie, crane, butterfly, plum, orchid, bamboo and chrysanthemum, pine tree, peony, daffodil, lotus,symbolizing "Longevity Ruyi", "Everlasting Peace", "A harmonious union lasting a hundred years", etc.

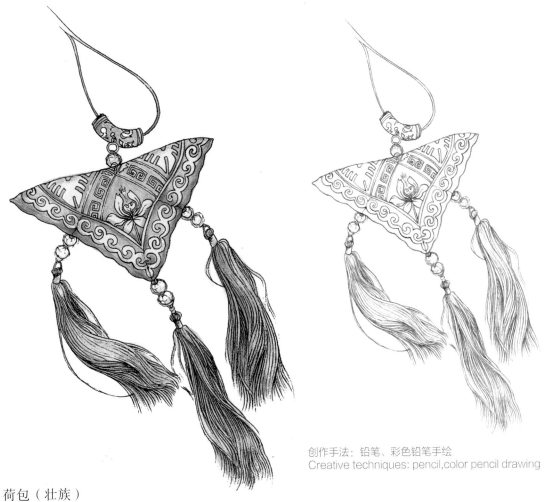

创作手法：铅笔、彩色铅笔手绘
Creative techniques: pencil,color pencil drawing

荷包（壮族）
The purse (the Zhuang ethnic group)

绣球纹样
Embroidered balls pattern

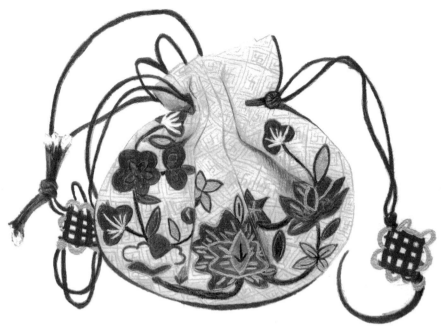

创作手法：彩色铅笔手绘
Creative techniques: color pencil drawing

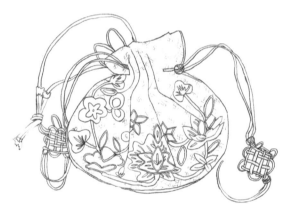

荷包（朝鲜族）
The purse (the Chaoxian ethnic group)

　　荷包上的金达莱（映山红）被朝鲜族誉为"花中西施"，每年盛冬之末初春来临之际，密密层层、叠锦堆秀地盛开于山野间，红艳热情，象征坚贞、美好、吉祥、幸福。

The Jindalai (azalea) on the purse is hailed as the Flower Beauty by the Chaoxian people. Every year when the winter leaves and the early spring arrives, azalea blooms densely in the mountains like piles of brocades. The redness symbolizes passion and the pattern symbolizes loyalty, beauty, auspiciousness and happiness.

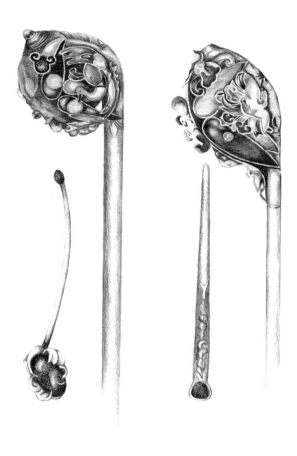

创作手法：彩色铅笔手绘
Creative techniques: color pencil hand-painting

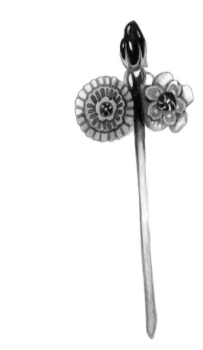

发簪（朝鲜族）
The hairpin (the Chaoxian ethnic group)

　　朝鲜族发簪除了用来装饰，还用来盘辫子，受力较重，因此会比较粗长。

The Chaoxian people use hairpins for not only decoration, but holding heavy braids as well. therefore,the hairpins are normally thick and long.

创作手法：计算机软件制图
Creative techniques: computer
software drawing

徽州石雕牌坊草龙纹 （汉族）
wood aura dragon pattern of Huizhou stone memorial archway (the Han ethnic group)

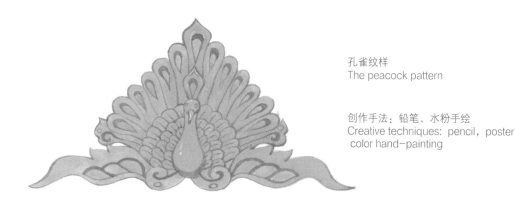

孔雀纹样
The peacock pattern

创作手法：铅笔、水粉手绘
Creative techniques: pencil, poster
color hand-painting

建筑上的孔雀纹与植物纹（傣族）
The peacock pattern and plant pattern on architecture (the Dai ethnic group)

以孔雀纹为背景的图案，单独纹样或成二方连续，变化较多，色彩清新漂亮，是傣族青年结婚志喜之物，象征美丽、吉祥和善良。

植物纹样常见的有菩提树、刺花、芭蕉树、芭蕉花、四瓣花、红毛树花，这些植物图案真实再现了傣族的生存环境，也表达了傣族人民的爱美心理。

The design with the peacock pattern as background contains separate patterns or continuous patterns in two directions, with changes and nice fresh colors. Such design is the happy marriage sign for young men and women of the Dai ethnic group, symbolizing beauty, auspiciousness and kindness.

The images of Linden, thorn flower, banana tree, banana flower, four petal flower and rambutan tree flower are commonly seen in plant patterns. Such plant patterns truthfuliy reproduce the living environment of the Dai people, and also express their love for beauty.

卷云塔纹样
The curly cloud and
tower pattern

心莲卷纹样
The lotus pattern

金水纹样
The golden water pattern

创作手法：铅笔、水粉手绘
Creative techniques: pencil，poster color hand-painting

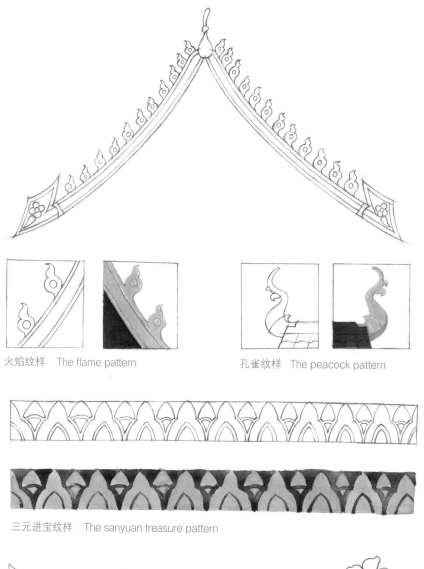

火焰纹样　The flame pattern

孔雀纹样　The peacock pattern

三元进宝纹样　The sanyuan treasure pattern

孔雀纹样
The peacock pattern

牡丹纹样
The peony pattern

牵牛花纹样
The morning glory pattern

创作手法：铅笔、水粉手绘
Creative techniques: pencil, poster color hand-painting

建筑上的孔雀纹与植物纹（傣族）

The peacock pattern and plant pattern on architecture (the Dai ethnic group)

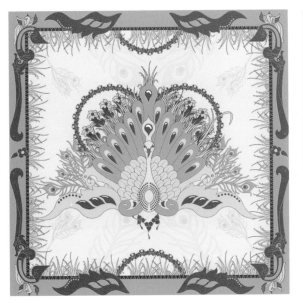 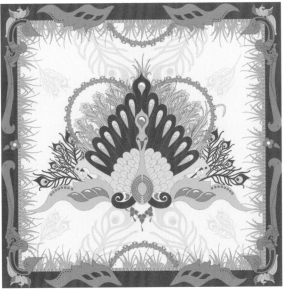

创作手法：计算机软件制图
Creative techniques: computer software drawing

孔雀纹与植物纹的创新设计
Innovative design of the peacock pattern and plant pattern

创作手法：计算机软件制图
Creative techniques: computer software drawing

象纹与植物纹的创新设计
Innovative design of the elephant pattern and plant pattern

创作手法：铅笔、水粉手绘
Creative techniques: pencil and poster color hand-painting

彩绘家具（哈萨克族）
The painted furniture (the Kazakh ethnic group)

　　哈萨克族传统木制家具使用镂刻、镶嵌和彩绘等手法进行装饰。其中，镂刻装饰手法多是在木桌侧面、木箱中心和侧面、木柜正面雕制出不同的几何纹（如三角形、方形、菱形等）、角纹和花卉纹等，并配以不同的二方连续和四方连续图案。哈萨克族图案基本的图样形式中心多为单独或四方连续的植物纹，四周以三角形等几何形围合，外层多是连续的花纹形，在方、圆和三角形之间找到形式的互补与和谐。哈萨克族图案在长期的经验积累下形成了更多的形式色彩面貌。红、绿、黑、蓝、黄等纯色在图案中以不同的形式原则加以使用。善于运用明度和纯度的对比原理，其中在纯度对比中黑色作底和红色图案的搭配最具特色，其他常见的如绿底配红图案，蓝底配黄图案或红底配蓝图案。明度对比主要使用在图案的勾边上，起到加强立体感的作用，如红图案勾白边或黄边，蓝图案勾黄边，在黑底红图案上勾浅绿的边最常见，这样的图案显得醒目有精神。

创作手法：铅笔、水粉手绘
Creative techniques: penci and poster color hand-painting

Kazakh's traditional wooden furnitures are decorated using engraving, inlay, and color painting techniques. Among them, the engraving decoration technique employed to produce different geometric patterns (such as triangles,squares,diamonds), and corner patterns, with two-square continuous and four-square continuous and four-square patterns mostly on the side of the wooden table, the center and the side of the woodcn box,and the wooden cabinet's front. The center of the Kazakh patterns' is mostly a single or four-sided continuous plant pattern, surrounded by triangles and other geometric shapes, and the outer layer is mostly a continuous pattern. Complementarity and harmony in form are obtained between squares, circles, and triangles. Kazakh's patterns have formed more formal and colorful features through the accumulation of long-term experience. Pure colors such as red, green, black, blue, and yellow are used in different forms among the group. The contrast principle of brightness and purity is widely used. And the matching of black background and red pattern is the most distinctive in purity contrast. Other common ones are green background with the red pattern, blue background with yellow pattern, or red background with the blue pattern. Brightness contrast is mainly used on the border of the pattern to enhance the three-dimensional effect. For example, the red pattern is on the white or yellow side, the blue pattern is on the yellow side, and the light green side on the red pattern on the black background is most common to show that the pattern is eye-catching and energetic.

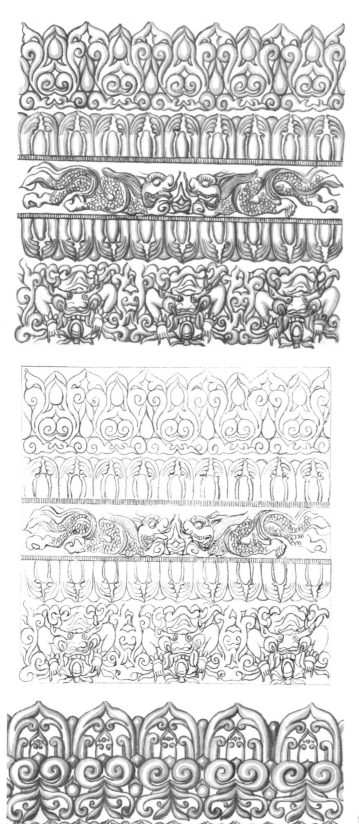

创作手法：水粉手绘
Creative techniques: poster color
hand painting

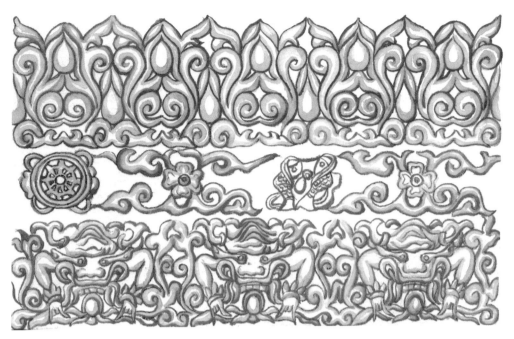

创作手法：水粉手绘
Creative techniques: poster color hand painting

镶八瑞相铜莽号纹样局部（藏族）
The long bronze trumpet inlaid with the Eight Buddhist Treasures (the Tibetan ethnic group)

这一套完整的图案取自藏族传统法器——镶八瑞相铜莽号现收藏于中央民族大学民族博物馆，是藏区本土乐器，藏语称"筒钦"，音色低浑、厚实，常作为引奏，带有"召唤""传播"的意味。图案排列方式均是二方连续，增加了宗教仪式的庄重感，图案包括几何纹样、吉祥八瑞、莲花和龙纹等常用的纹样造型，寓意吉祥，庄严大气。

This complete set of pattern is taken from the traditional Tibetan musical instrument, the long bronze trumpet inlaid with the Eight Buddhist Treasures (now kept at The Museum of Ethnic Cultures of Minzu University of China). This native Tibetan musical instrument is called "Tongqin" in Tibetan language and it plays low notes. The instrument is thick and is often used as an introduction, with the meaning of "calling" and "spreading". The design which is continuous in two directions to increase the solemnity of religious ceremonies includes geometric patterns, the auspicious Eight Buddhist Treasures, lotus and dragon patterns and other commonly used shapes which imply auspiciousness and solemnity.

白海螺：藏族以右旋白海螺最受崇拜，象征名声远扬四方。

White conch shell: The right-handed white conch shell is the most worshipped treasure by the Tibetans. It symbolizes good reputation around the world.

创作手法：水粉手绘
Creative techniques: poster color hand painting

银壶纹样（藏族）
Silver pot patterns (the Tibetan ethnic group)

 左图为藏族银壶上提取的纹样，壶盖顶端为莲花纹，壶身上段主体由吉祥八宝中的宝瓶和开花的石榴组成，壶身中段由龙纹和结果的石榴树组成，壶身下段为果实成熟的石榴树。

The picture on the left shows the lotus pattern extracted from the top of the lid of the silver Tibetan pot. The main body of the pot body is composed of the treasure vase of the Eight Buddhist Treasures and blooming the pomegranate; the middle part of the pot body is composed of the dragon patterns and fruiting pomegranate trees; the lower part of the pot body is a pomegranate tree with ripe fruits.

 宝瓶：藏语称"崩巴"，瓶内装净水和宝石，瓶中插有孔雀翎和如意树。

Treasure vase: "Bengba" in Tibetan language. The vase contains clean water and precious stones, and holds peacock feathers and a wishful tree. The treasure vase symbolizes auspiciousness.

 卷草纹：由印度佛教传入，形成于汉代，但因兴盛于盛唐时期，因此也称为"唐草纹"。图案为 S 形二方连续，造型圆润。

The curly grass pattern: It was introduced by India's Buddhism and formed in the Han Dynasty, and it was also called "Tang grass pattern" because it flourished in the Tang Dynasty. The pattern is S-shaped and continuous in two directions with round shapes.

 龙纹：作为皇权的象征，寓意吉祥如意、尊贵与守护。

The dragon pattern: The dragon pattern appeared as a symbol of imperial power, implying good luck, nobleness and guardianship.

 莲花纹：莲花象征圣洁吉祥，象征佛法之纯净无染。

The lotus pattern: The lotus flower symbolizes holiness and auspiciousness, and the purity of Buddhism.

 卷叶纹：藏族植物纹的代表。这种从植物的自然形态提取的卷绕或螺旋状的花叶，抽象化，无限反复。从花叶的顶端开始不断变化，由写实向抽象转变，最终变得图形化、几何化。

The curly leaf pattern: A representative of Tibetan plant patterns. The winding or spiral flowers and leaves extracted from the natural form of plants are abstracted and repeated endlessly. Starting from the top of the flowers and leaves, the pattern changes continuously from realism to abstraction, making it graphical and geometric.

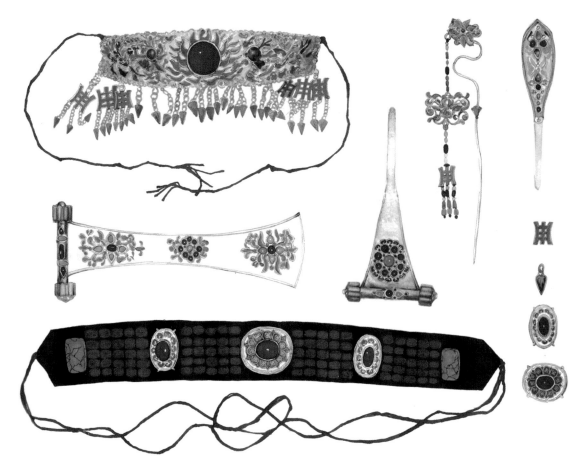

创作手法：水粉手绘
Creative techniques: poster color hand painting

参考图片来源：乔玉光 编撰 . 内蒙古蒙古族传统服饰典型样式（上）[M]. 内蒙古人民出版社，2014：167.

头饰纹样（蒙古族）
Headdress patterns (the Mongolian ethnic group)

支此头饰纹样来自蒙古族敖汉部落，该地区头饰主要由两条额带、两支竖簪、两支托簪、一支扁方、一对发筒和一对挂住簪组成 。

The headdress pattern is from the Mongolian Aohan tribe whose headdress patterns are mainly composed of two forehead bands, two vertical hairpins, two support hairpins, one flat hairpin, a pair of hair barrels and a pair of hanging hairpins.

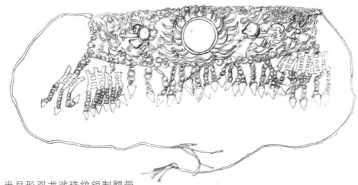

半月形双龙戏珠纹银制额带
A silver forehead band with the half-moon shaped
pattern of two dragons playing a fireball

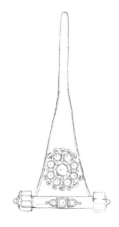

莲瓣状簪首花瓣纹竖簪
A vertical hairpin with the lotus
petal-shaped head and petal pattern

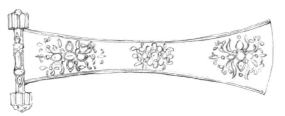

杏花纹扁方
Bian Fang (a characteristic headdress worn by Manchu women in
the Qing Dynasty) with the apricot blossom pattern

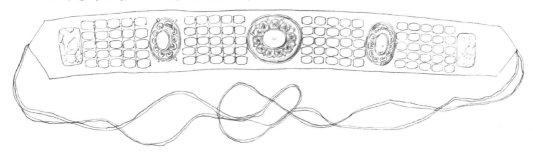

龙头形连瓣簪首
The hairpin head with the dragon
head-shaped lotus petal

蝴蝶形挂饰
A butterfly-shaped
hanging ornament

兰萨图案挂饰
A hanging ornament
with Lansa design

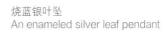

烧蓝银叶坠
An enameled silver leaf pendant

椭圆形云纹银饰
An oval silver ornament with
the cloud pattern

椭圆形花瓣纹银饰
An oval silver ornament with
the petal pattern

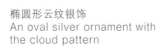

创作手法：铅笔手绘
Creative techniques: pencil drawing

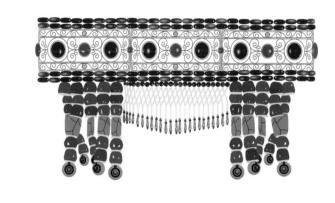

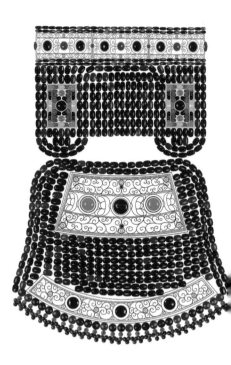

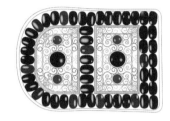

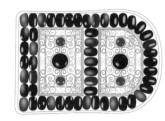

创作手法：计算机软件制图
Creative techniques: computer software drawing

参考图片来源：乔玉光 编撰 . 内蒙古蒙古族传统服饰典型样式（上）[M]. 内蒙古人民出版社，2014：450.

头饰纹样（蒙古族）
Headdress patterns (the Mongolian ethnic group)

此头饰纹样来自蒙古族鄂尔多斯部落，鄂尔多斯部落头饰主要有头箍、额饰、鬓角垂饰、颞部垂饰、练椎、脑后饰、胸饰。

This headdress pattern comes from Ordos tribe of Mongolian. The Ordos tribe's headdress is mainly composed of headbands, forehead ornaments, temple pendants, temporal pendants, cone bun, back ornaments and chest ornaments.

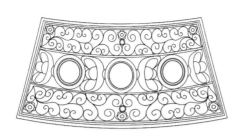

鄂尔多斯部落纹样提取
Extraction of the Ordos tribal patterns

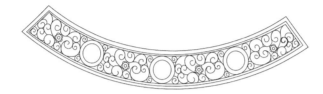

女式礼仪帽
A women's dress hat

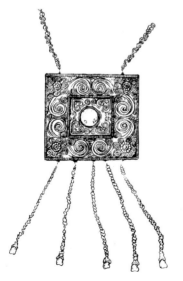

圆形银饰
A silver round ornament

长方形银饰
A rectangle silver ornament

胸饰
A chest ornament

创作手法：铅笔手绘
Creative techniques: pencil drawing

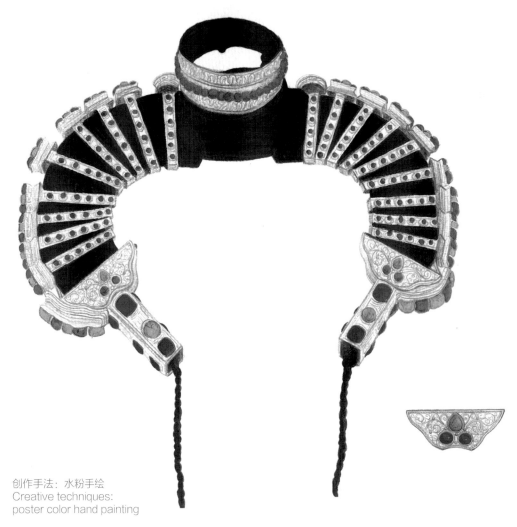

创作手法：水粉手绘
Creative techniques:
poster color hand painting

参考图片来源：乔玉光 编撰 . 内蒙古蒙古族传统服饰典型样式（上）[M]. 内蒙古人民出版社，2014：7.

头饰纹样（蒙古族）
Headdress patterns (the Mongolian ethnic group)

　　此图案来自蒙古族巴尔虎部落已婚女子的头饰，头饰造型呈盘羊角形，在条形银饰上镶嵌珊瑚、松石等宝石。

This pattern comes from the headdress of a married woman from the Mongolian Barga tribe. The headdress is in the shape of an argali and is inlaid with precious stones such as coral and turquoise on the silver bar.

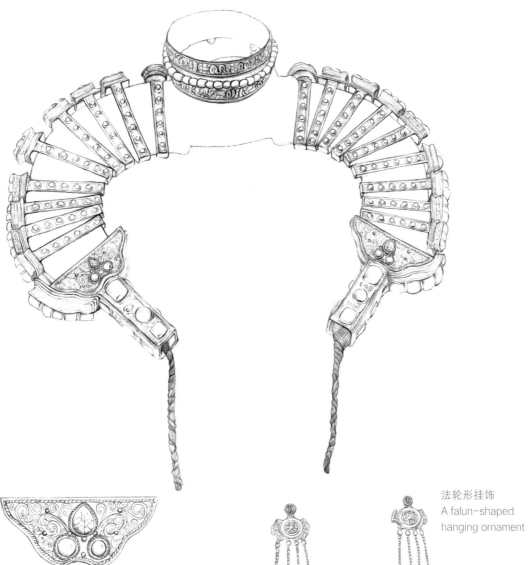

卷草纹装饰
An ornament with the curly grass pattern

回纹装饰
An ornament with the fret pattern

条形银饰
A stripe silver ornament

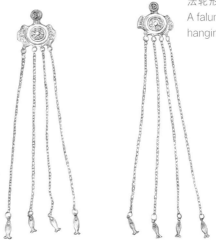

法轮形挂饰
A falun-shaped
hanging ornament

银鱼挂坠
A fish-shaped silver hanging ornament

创作手法：铅笔手绘
Creative techniques: pencil drawing

创作手法：计算机软件制图
Creative techniques: computer software drawing

巴尔虎部落纹样提取与创作（蒙古族）
Extraction and design of the Barga tribal patterns (the Mongolian ethnic group)

创作手法：计算机软件制图
Creative techniques: computer software drawing

巴尔虎部落纹样提取与创作（蒙古族）
Extraction and design of the Barga tribal patterns (the Mongolian ethnic group)

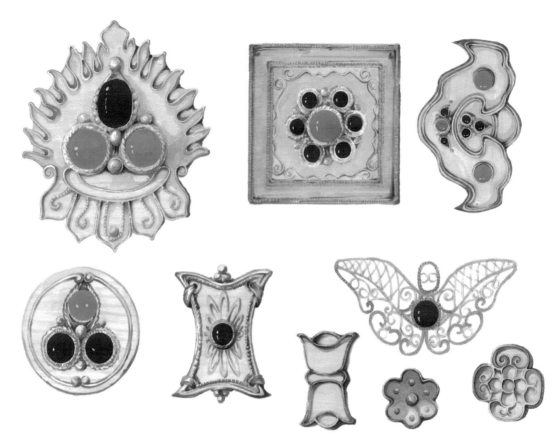

创作手法：马克笔手绘
Creative techniques: color marker pen drawing

参考图片来源：乔玉光 编撰 . 内蒙古蒙古族传统服饰典型样式（上）[M]. 内蒙古人民出版社，2014：217.

头饰纹样（蒙古族）
Headdress patterns (the Mongolian ethnic group)

　　此纹样来自蒙古族克什克腾部落，茫茫塞外，碧空如洗，克什克腾部落传统服饰古朴素雅，头饰额箍由两排镶宝石镂花银饰片组成，下接造型流畅的珊瑚、松石珠穗。

This pattern comes from the Mongolian Hexigten tribe. Beyond the Great Wall, the blue sky is clean as if it has just been washed. The traditional costume of the Hexigten tribe is simple and elegant. The headband of the headdress is composed of two rows of silver ornaments inlaid with gemstones, followed by smooth coral and turquoise tassel.

火纹形如意图案银饰
A flame-shaped silver ornament with
the Ruyi pattern

蝙蝠形如意图案挂饰
A bat-shaped hanging ornament
with the Ruyi pattern

圆形如意图案银饰
A silver round ornament
with the Ruyi pattern

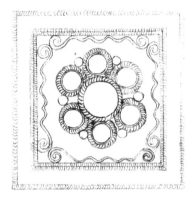

正方形花瓣纹犄纹银饰方
A square silver ornament with petal and horn pattern

月牙组合形银饰
A crescent moon silver ornament

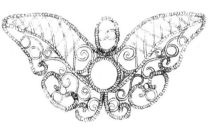

蝴蝶形挂饰
A butterfly-shaped hanging ornament

花瓣形云纹挂饰
A petal-shaped hanging ornament
with the cloud pattern

花瓣型挂饰
A petal-shaped hanging
ornament

元宝组合挂饰
A combined ingot hanging
ornament

创作手法：铅笔手绘
Creative techniques: pencil drawing

蝴蝶型云纹银饰
A butterfly-shaped silver
ornament with the cloud
pattern

犄纹卷草纹银饰
A silver ornament with horn
and curly grass patterns

月牙组合形银饰
A crescent combined silver
ornament

创作手法：计算机软件制图
Creative techniques: computer software drawing

参考图片来源：乔玉光 编撰 . 内蒙古蒙古族传统服饰典型样式（上）[M]. 内蒙古人民出版社，2014：88.
参考图片来源：乔玉光 编撰 . 内蒙古蒙古族传统服饰典型样式（上）[M]. 内蒙古人民出版社，2014：216.
参考图片来源：乔玉光 编撰 . 内蒙古蒙古族传统服饰典型样式（下）[M]. 内蒙古人民出版社，2014：366.

蒙古族头饰纹样提取习作
Extraction practice of the Mongolian headdress patterns

创作手法：计算机软件制图
Creative techniques: computer software drawing

四方连续图案创作
Design of continuous patterns in four directions

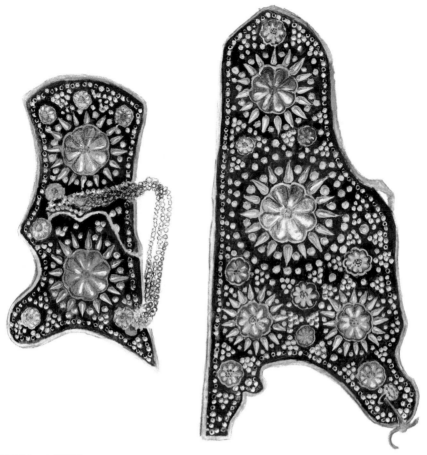

创作手法：水粉手绘
Creative techniques: poster color hand painting

黑绒嵌银花撒袋（蒙古族）
A black velvet sack embedded with silver flowers (the Mongolian ethnic group)

这是乾隆二十一年（公元 1756 年）蒙古族土尔扈特部台吉敦多布达什进呈乾隆皇帝的弓袋和箭袋。黑绒底上有金属花装饰，弓袋和箭袋的羊皮条上写"土尔古特台吉敦多布达什恭进撒袋一副，乾隆二十一年"。

This is the bow bag and quiver presented to Emperor Qianlong by the noble Dunduobu Dashi from the Mongolian Torghut tribe in the 21st year of the Qianlong reign (AD 1756). The black velvet background is decorated with metal flowers, and the sheepskin strips of the bow bag and quiver read "from the noble Dunduobu Dashi of the Mongolian Torghut tribe, a pair of sacks, in the 21st years of the Qianlong reign".

弓袋长 62 厘米、宽 29 厘米；箭袋长 42 厘米、宽 21 厘米。
The bow bag is 62 cm long and 29 cm wide; the quiver is 42 cm long and 21 cm wide.

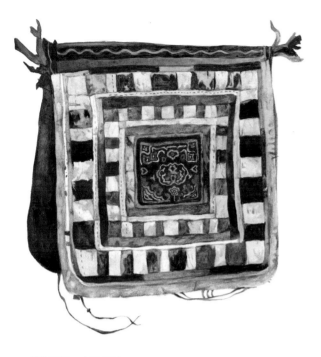

兽皮拼制绣花兜（鄂伦春族）
An embroidered bag with combined animal skins (the Oroqen ethnic group)

鄂伦春族的兽皮文化有着悠久的历史，沿用原始的鞣皮和制皮工艺，兽皮制品种类丰富，装饰纹样古朴美观，独具特色，充分体现了游猎民族的生活习俗。

The Oroqen people's animal skin culture has a long history, and it inherits the primitive tanning and leather-making techniques. The various and unique animal skin products carry simple and beautiful decorative patterns, which fully reflect the living customs of the hunting people.

创作手法：水粉手绘
Creative techniques: poster color hand painting

桦树皮包（达斡尔族）
An birch bark bag (the Daur ethnic group)

桦树皮制品轻便、防水、不怕磕碰，最适合达斡尔族游猎迁徙的生活方式。达斡尔族在用桦皮做的桶、盒、箱等上面以墨绘制图案，纹样有草木、山水、鸟兽、亭阁等，再涂上一层桐油，能保持图案不退色。

The lightweight, waterproof and tough birch bark products are very suitable for the safari and migration of the Daur people. Patterns such as grass and trees, mountains and rivers, birds and wild animals and pavilions are drawn in ink on buckets, cases and boxes made of the birch bark, and then a layer of tung oil is applied to keep the pattern coloring.

创作手法：水粉手绘
Creative techniques: poster color hand painting

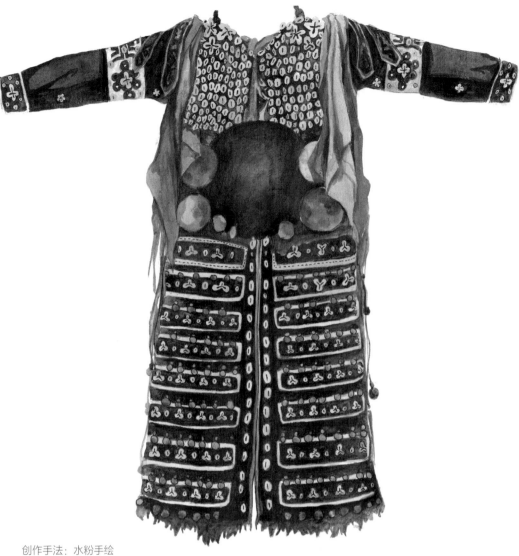

创作手法：水粉手绘
Creative techniques: poster color hand painting

萨满神服（鄂伦春族）
The shaman costume (the Oroqen ethnic group)

　　萨满披肩：达斡尔族人的萨满披肩一般用黑坎布缝制，镶有白边。坎肩上镶嵌着365个海螺，排列成花饰，代表一年有三百六十五天。螺也是人丁兴旺和幸福安宁的象征。在披肩的左右肩上各放一只木雀，也叫"信息鸟"，是萨满的使者。

　　萨满长袍：达斡尔族的萨满服，款式多是用熟兽皮制作的长袖对襟长袍。一般而言，从领口到下摆钉着8个大铜纽扣，左右袖口及下摆处都有黑大绒装饰，黑色皮条上面绣有鹿角花纹或植物花草。达斡尔族的萨满服以铜纽、铜铃、铜镜为其主要装饰。长袍下摆的大绒处左右各钉有15只铜铃，在长袍左右衣襟之间各钉15面小铜镜，神服背面悬有5面铜镜。

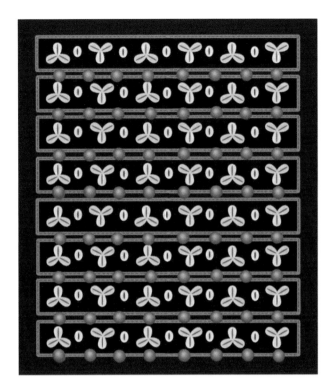

萨满神服贝壳图案提取
Extraction of Shaman costume shell patterns

创作手法：计算机软件制图
Creative techniques: computer software drawing

The shaman shawl: A shaman shawl with white edges is usually sewn with black cloth. The vest is inlaid with 365 conch shells arranged in a floral ornament, representing 365 days in a year and symbolizing prosperity, happiness and peace. A wooden bird, which is also called a "messenger bird", is placed on the left and right shoulders respectively. The divine bird is Shaman's messenger.

Shaman robe: The Shaman robes of the Daur are mostly long-sleeved robes made of cooked animal skins with red silk lining. In general, 8 large copper buttons pinned from the collar to the hem with black velvet decoration on cuffs and hem, and the black leather strip is embroidered with the deer antler patterns or plants and flowers. The shaman robes of the Daur use copper buttons, copper bells, and bronze mirrors as their main decoration techniques. 15 copper bells are nailed at the big velvet on the left and right sides of the robe hem respectively, 15 small bronze mirrors between the left and right plackets of the robe, and another five bronze mirrors hung on the back of the robe.

创作手法：水粉手绘
Creative techniques: poster color hand painting

兽皮手套（鄂伦春族）
Animal skin gloves (the Oroqen ethnic group)

　　装饰图案主要是刺绣而成的。鄂伦春族早期曾用骨针和兽筋线进行皮手套、马褡子、门帘、烟荷包等皮革制品的绣制，图案多以花草树木和走兽等自然纹样为主。刺绣在皮革上的图案，通常要先剪出纸样，然后依样画在皮革上再进行刺绣。

The decorative patterns are mainly embroidered. The Oroqen people used bone needles and animal tendons to embroider leather products such as leather gloves, horse saddles, door curtains, and cigarette purses. The patterns were mostly natural including flowers, trees, and animals. The pattern embroidered on the leather usually needs to be cut out first, and then drawn on the leather according to the pattern before embroidering.

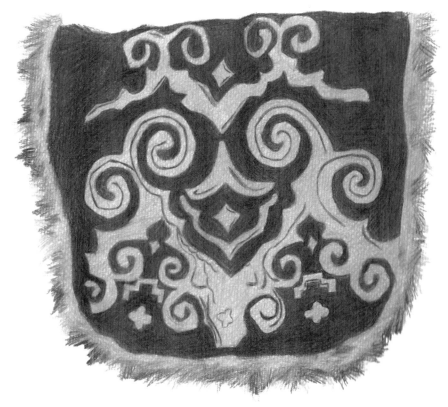

创作手法：水粉手绘
Creative techniques: poster color hand painting

"卡皮参"背包（鄂伦春族）
A "Kapican" backpack (the Oroqen ethnic group)

"卡皮参"利用多种毛色动物的皮革拼接而成，镶嵌出
各种图案，给人一种朴实粗犷的感觉。

A "Kapican" usually adopts the combination
of natural coat colors of a variety of animals and
various inlaid patterns to make it simple but rough.

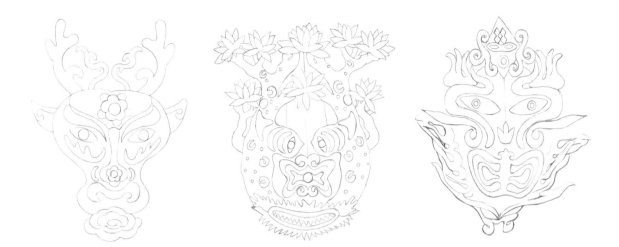

创作手法：铅笔手绘
Creative techniques: pencil drawing

鱼皮面具（赫哲族）
The fish skin mask (the Hezhe ethnic group)

　　鱼皮艺术是赫哲族特有的工艺品制作形式。制作手法多为对鱼皮进行粘贴、镂刻，是赫哲族的民族文化符号，极具观赏性、装饰性和艺术性。

Fish skin art is a unique form of craftsmanship of the Hezhe people. Being pasted and carved, they are the Hezhe people's ethnic cultural symbols which are highly ornamental, decorative and artistic.

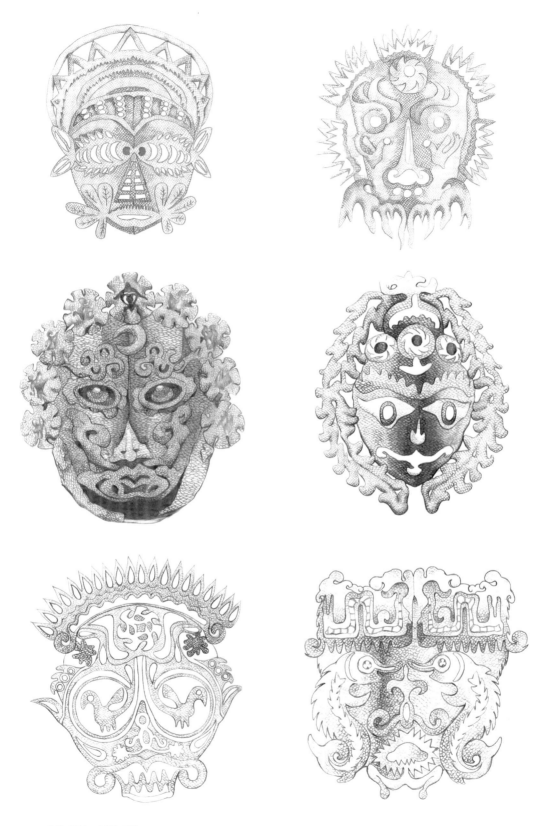

创作手法：铅笔手绘
Creative techniques: pencil drawing

"纹"以载道——中华民族传统纹样精品及创新设计展，在英国剑桥大学和奥地利维也纳的展厅现场
"Patterns for Tao" -- the exhibition of Chinese traditional patterns and innovative design, which was held
at the exhibition hall of Cambridge University in the UK and Vienna in Austria

后　记

　　中央民族大学美术学院始终坚持深入民族地区开展教育艺术调研，坚持推动民族纹样的传承与创新，60 余载默默耕耘，使理论教学、田野调查、实践创作三者之间良性互动，形成多元一体的民族艺术研究创作体系，成果丰硕。

　　俄国文艺理论家尼古拉·加夫里诺维奇·车尔尼雪夫斯基说过："艺术来源于生活，却又高于生活"，纹样就是来自于生活的艺术。本书课题组基于中央民族大学美术学院相关课程，致力于中国传统纹样的收集整理与应用再创作。此书准备工作始于 2004 年，课题组师生深入东北、西北、西南多地，开展民族纹样的搜集梳理、分类提取、创新设计等工作，逐渐形成了本书的基础素材。课题组深入西南地区调研时，得到贵州省博物馆与黔东南欧东花博物馆的大力支持，走访了当地许多非遗传承人及民间手工艺人，收集了大量刺绣、蜡染、银饰等手工艺作品，为西南地区的纹样研究和创作积攒了宝贵的一手资料。

　　2022 年，本书中作品展览"'纹'以载道——中华民族传统纹样精品及创新设计展"获国家艺术基金传播交流推广项目资助，课题组精选部分作品前往英国剑桥大学与奥地利维也纳举办展览和国际研讨。正如鲁迅先生所说："越是民族的，就越是世界的"，在信息高度发达的今天，海外观众依然为中国民族艺术之美所倾倒。"美"是世界通用语言，我们期望通过民族纹样之美展现中华民族文化自信，让中华民族艺术走上世界舞台。

　　中华民族艺术的传承创新与推广交流任重而道远，在此感谢为本书出版给予支持的各界人士，尤其对参与课题调研、作品创作、书稿编辑人员的辛勤付出和学校各级领导和各部门同事们的大力支持表示衷心感谢。感谢郑泽光大使为"纹"以载道海外展览题写亲笔贺信、感谢于芃公参、黄崇岭教授、于涛先生、剑桥大学的 David Cardwell 教授和 Nicola Clayton 教授，以及 Richard Trappl 教授和他的同事们、感谢他们对"纹"以载道海外展览的大力支持。

　　由衷感谢项目组成员的无私付出，没有他们此书的出版与展览的举办均难以实现。此书虽然历经数年准备，仍有诸多不足，诚挚希望诸君提出宝贵意见。

<div style="text-align: right">

徐　进

2023 年 3 月于北京

</div>

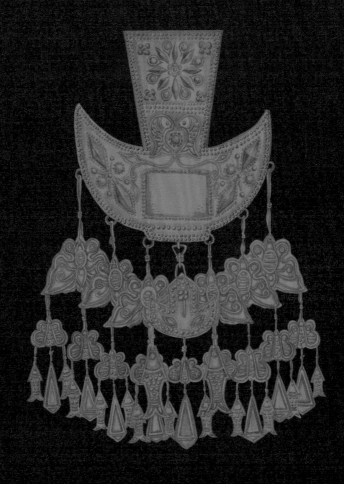

谨以此书献给致力于民族纹样保护、传承与推广的工作者们。

I would like to dedicate this book to the workers who are committed to the
protection, inheritance and promotion of ethnic patterns.